The Campus History Series

CENTRAL MICHIGAN
UNIVERSITY

JACK R. WESTBROOK

To Ruth, With hopes this book kindles fond memories of Central. Best Wishes Jack R Westbrook

ARCADIA
PUBLISHING

Published by Arcadia Publishing
Charleston SC, Chicago IL, Portsmouth NH, San Francisco CA

Printed in the United States of America

Library of Congress Catalog Card Number: 2007924799

For all general information contact Arcadia Publishing at:
Telephone 843-853-2070
Fax 843-853-0044
E-mail sales@arcadiapublishing.com
For customer service and orders:
Toll-Free 1-888-313-2665

Visit us on the Internet at www.arcadiapublishing.com

*Dedicated to Judge Samuel W. Hopkins, who led the
formation of the Mount Pleasant Improvement Company
(Charles Brooks, John W. Hance, Michael Devereaux,
A. S. Countant, Isaac Fancher, Douglas H. Nelson, George
Dusenbury, L. N. Smith, M. Lower, Wilkinson Doughty, and
F. D. Patterson), the founding body of what would someday
become Central Michigan University, and to all the faculty,
staff, and alumni who have taken Hopkins's dream
to the reality of a world-class learning venue.*

CONTENTS

ACKNOWLEDGMENTS

Unless otherwise indicated here, photographs in this book were scanned from photograph files of the Clarke Historical Library, Central Michigan University, Mount Pleasant. Modern campus scenes were captured by the author. Thanks to those who wove the rich tapestry that has become Central Michigan University, a few threads of which may be viewed herein. Thanks to Arcadia Publishing acquisition editor Anna Wilson and publisher John Pearson (in the Chicago office) and publicity manager Emily Miller and regional sales manager Meg Firebaugh (in Mount Pleasant) for their help bringing this book from my keyboard to your lap. Thanks to Frank Boles, director; Marian Matyn, archivist; John Fierst, reference librarian; Tanya Fox, researcher; Heather Anton, student assistant; and Pat Thelan scanning/digitizing specialist, all of the Clarke Historical Library at Central Michigan University for helping find and prepare many photographs for publication. Thanks also to Central Michigan University's dean of libraries Thomas J. Moore, vice president of development and alumni relations Michael A. Leto, and director of library development and community outreach Brian A. Palmer for their encouragement of this project. Thanks to Central Michigan University graduate students Michael W. Phillips and Robert J. Hendershot, whose Buildings of Central Michigan University Web site project was an inspiration and a valuable resource for this book. A special thanks to Tom Williams of Mount Pleasant, whose gracious loan of the family heirloom photograph on page 2 serves as the ideal cornerstone for this volume, and to Tom Williams Jr., of Grand Rapids, for his enhancement magic turning the "no contrast" sepia print into something usable. Thanks also to Dolores Lawrence of Mount Pleasant for the loan of the aerial picture of campus on page 77 that illustrates the impact of automobiles on the campus scene so well. Thanks to the people who made the Central Michigan University Web site, www.cmich.edu, an outstanding research resource. Credit for the Michigan Oil and Gas exhibit photograph on page 120 belongs to the *Michigan Oil and Gas News* magazine, a wholly-owned subsidiary of the Michigan Oil And Gas Association, Frank L. Mortl, a 1971 Central graduate, president. Thanks to retired Clarke Historical Library director John Cumming, who was kind enough to review this effort. Cumming's two books, *The First Hundred Years: A Portrait of Central Michigan University 1892–1992* and *This Place Mount Pleasant*, were invaluable in this project. A word of thanks to all those who contributed to the vast historical photographic and other materials available from the Clarke Historical Library. Most of all, thanks to the readers of my middle Michigan photographic history series, whose kind comments, gentle tolerance, and continued custom have made this a gratifying experience.

INTRODUCTION

In 1932, oil exploration and production brought my father's parents to Mount Pleasant. Years later, the oil industry provided me a career chronicling its triumphs and tragedies weekly as editor of the *Michigan Oil and Gas News* magazine, so the industry is my friend. Mount Pleasant gave me a safe, stable place to grow up, later to launch five magnificent human beings to succeed in working worlds of their choosing and now to enjoy retirement, so the town is my friend. When I was 12 years old, a Central student teacher instilled in me a love of putting ink on paper. The passion that has taken me from newsboy to pressroom worker to advertising sales and management to magazine editorship to authorship along a 55-year adventure to date. Later Central provided me with a great learning experience and more recently was an outstanding research resource for my books. So the college is my friend.

Lucky me. In my previous Arcadia books, I have told the stories of *Michigan Oil and Gas* and *Mount Pleasant*. Completing this book, *Central Michigan University*, puts the final piece in my middle Michigan photographic history trilogy, and I have now been able to tell the biographies of three of my best friends. Not many get such an opportunity.

Mount Pleasant was established in the early 1850s and named after his hometown of Mount Pleasant, New York, by lumberman David Ward, who first platted the village. Mount Pleasant was designated the Isabella County seat when the county was created in 1859. In early 1892, citizens of this fledgling, mountainless lumber town in Isabella County in central Michigan were inspired to establish an institution of higher learning and set about the project through an organization called the Mount Pleasant Improvement Company (MPIC). The company platted 224 lots and sold the majority of them by chance assignment for $110 each on 52 acres it had purchased for $8,000, setting aside 10 acres for the school they hoped would someday come to be.

On September 13, 1892, the first classes were held at Central Michigan Normal School and Business Institute upstairs over a drugstore at the southeastern corner of Main and Michigan Streets in downtown Mount Pleasant. A private enterprise, the school's premier class boasted a mighty enrollment of 31 students who gathered in the rented space located in a building destroyed by fire in the late 1990s.

The school's name was to change five more times from 1895 to the present, to be known as Central Michigan Normal School from 1895 to 1927, Central State Teachers College from 1927 to 1941, Central Michigan College of Education from 1941 to 1955, Central Michigan College from 1955 until 1959, and Central Michigan University from 1959 to present. These name changes came sometimes to the delight of Central officials and

the chagrin of those living and doing business along one of Mount Pleasant's principal north–south thoroughfares, who have had to change their stationery from "Normal" to "College" to "University" Avenue.

With a total enrollment of 27,452 (20,012 undergraduate and 7,440 graduate students), Central Michigan University is currently the state's fourth largest. The university offers its growing student population a broad selection of more than 3,000 individual courses and a choice of 25 degrees. Nearly 20,000 students live on the 480-acre campus in Central Michigan University's 6,441 student rooms housed at 22 residence halls. There are 811 full-time Central Michigan University faculty members and more than 160,000 alumni. In addition, the university has 41 off-campus centers of learning.

One

THE TRADITIONAL CAMPUS CORE
1892–1918

The first classes for Central Michigan Normal School and Business Institute were held in rented space upstairs in the Carpenter Building in downtown Mount Pleasant at the corner of Main and Michigan Streets. The first class of the private enterprise had 31 students. Shown here in the 1950s, the C. A. Clark sign was later replaced by one commemorating the school's start. The building was destroyed by fire in the late 1990s and remains a vacant lot where each spring, downtown Mole Hole store owner Cindy Neal plants a flower garden for the enjoyment of passersby.

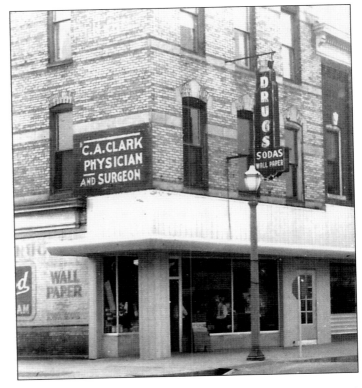

Prof. Charles F. R. Bellows from Ypsilanti wrote a number of textbooks and was a respected teacher when he became Central Michigan Normal School and Business Institute's first principal, until his early 1896 resignation, telling the state board of education he would step aside to make room for a younger man. He taught through summer school of 1896. Bellows Street, named for him, continues to be the northern campus perimeter street.

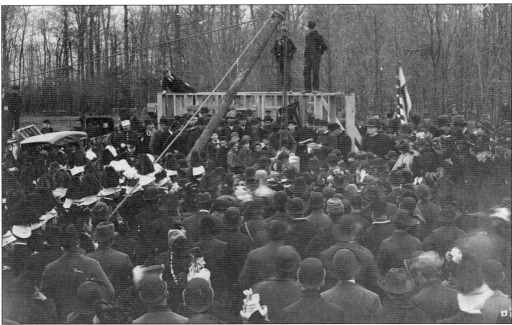

At the September 18, 1892, commencement ceremonies of the Central Michigan Normal School and Business Institute, Bellows officially broke ground for the school's first building on a 10-acre plot south of town. Bellows also presided over the November 19, 1892, above, laying of the cornerstone of that first building in ceremonies conducted under the auspices of the Knights of Pythias.

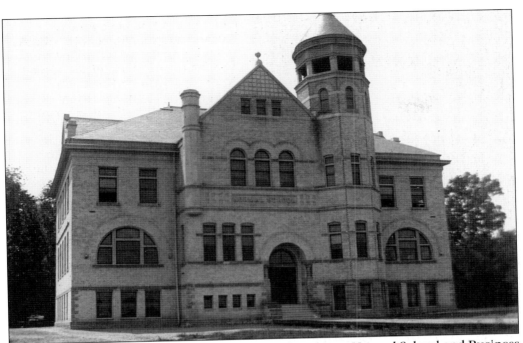

Construction of the first building on the Central Michigan Normal School and Business Institute campus was completed in 1893. The new main administration building remained a focal point of the fledgling school for 32 years and saw the campus expansion from 10 to 25 acres in 1894 to encompass the area from Bellows to Preston between Main and Franklin Streets.

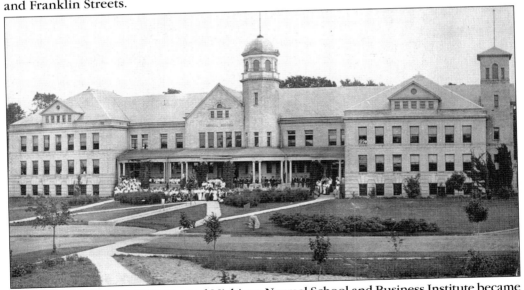

In private hands until 1895, Central Michigan Normal School and Business Institute became Central Michigan Normal School, a state institution, that year. The main administration building was augmented by a wing addition to the west in 1899, with another added to the west in 1902 to meet growing space needs of the robust young school. This 1906 commencement included the dedication of a new sundial in front of the structure.

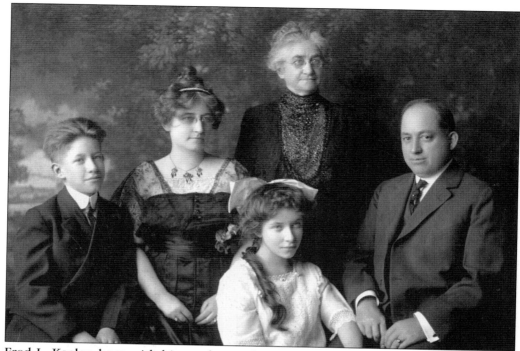

Fred L. Keeler, here with his mother, wife, and two children, was appointed to the faculty of Central Michigan Normal School in 1895 as an instructor, also heading the Department of Science. In 1908, Keeler left Central to become deputy superintendent of public instruction at Lansing. In 1913, he was appointed superintendent of public instruction and was elected to that position until his 1918 death at age 46.

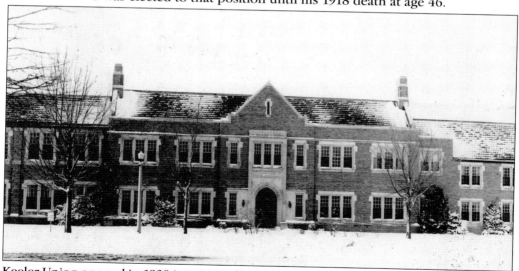

Keeler Union opened in 1939 just west of Warriner Hall. Central's first student union was in the wing facing north, with a 90-bed dormitory (now a segment of Barnes Hall) facing west on the east side of Washington Street. The first floor of the union was occupied by a cafeteria, men's lounge, game room, and grand stairway to the second floor women's lounge, billiards room, and grand ballroom.

Principal of the Normal Department at Olivet College from 1889, Charles McKenny of Diamondale was appointed Central's second principal in 1896 until his 1899 resignation to accept a position in Milwaukee, Wisconsin. McKenny's first year as principal saw Ernest Koyl of Fremont and Percy Glanville of Newaygo bicycle to Mount Pleasant and enroll at Central, expanding the enrolled students beyond the immediate Isabella County area.

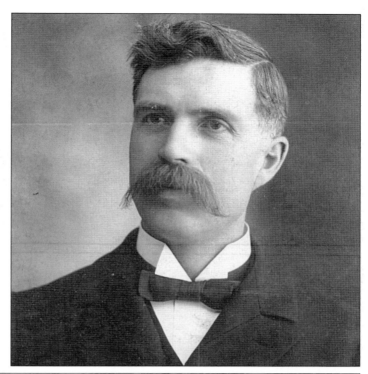

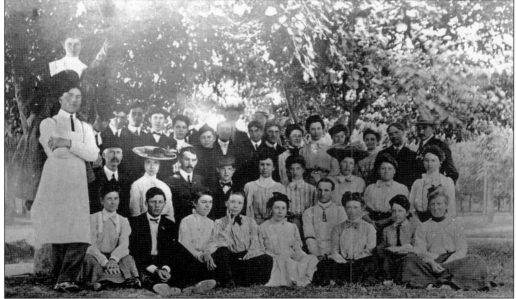

Early Central students were faced with no on-campus housing, living either at home or at nearby boardinghouses, where demand for housing soon outstripped supply. Principal Bellows publicly appealed to community citizens to provide room and board for students. A group of investors, including Bellows, built the three-story normal school boardinghouse with 23 student rooms, for which up to 50 students (like this group) paid $2.50 per week.

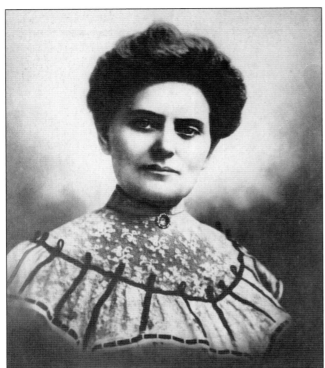

A formidable woman, Lucy A. Sloan "was the heart and soul in the suffrage movement," according to her 1918 obituary. Sloan had taught at Kentucky's Berea College and in Lansing city schools before coming to Central Michigan Normal School as preceptress in 1897. Later she became head of the English department, a recognized speaker, and a textbook author who formed Central's first literary society for women in 1918.

Lucy Sloan Hall opened in 1941 to house 148 women on the top two floors. A 20-bed health services facility occupied the southern ground floor. Redesigned in 1963 as the Sloan Pan-Hellenic House, the building was home to eight sororities. Sloan Hall became home of the departments of economics, finance, and psychology, as well as the office of gay and lesbian programs in 1970.

After graduating in 1889 from Eastern Michigan College, Rachel Tate went to Harvard, then the University of Chicago for graduate work. She came to Central following service as a grade school teacher in Chicago, commissioner of schools at Berrien County, and a teacher at Benton Harbor, Michigan, as well as St. Mary's College in Illinois. From 1897 to 1916, she was an instructor in Central's English department and a part-time dean of women.

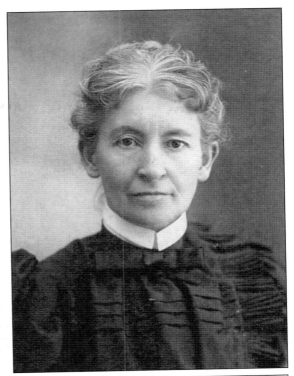

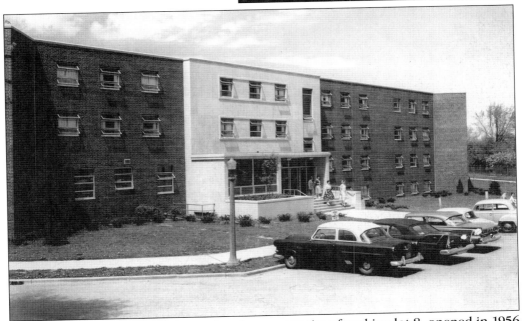

Rachel Tate Residence Hall, located at the current site of parking lot 8, opened in 1956 as the first women's residence hall at Central to use a suite plan, a second bedroom added to the traditional single room. The hall's 75 suites were a campus home for women students, going to coed occupancy in 1972. Low enrollment and high remodeling cost estimates brought about the 1997 demolition of the hall.

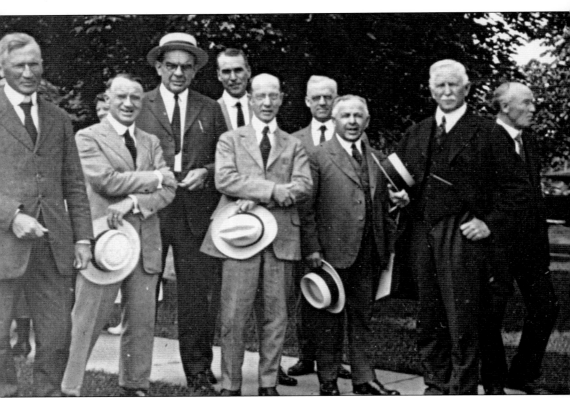

Charles Grawn, originally from Salem, left his 15-year position as superintendent of schools at Traverse City in 1899 to become superintendent of the training school at the normal school at Mount Pleasant. In 1900, he became principal, and later president, of Central Michigan Normal School. During his tenure, the training school, power plant, gymnasium, and science building were built and the campus grew to 25 acres. Plagued by the effects of a poor national economy and World War I on Central's enrollment, Grawn retired in 1918. In this remarkable photograph, Grawn is shown, second from the right, with, from left to right, eight faculty members (six of whom, besides Grawn, have campus buildings named for them) in 1916: Charles F. Tambling, Myron A. Cobb, R. D. Calkins, Kenneth P. Brooks, Claude Lazelere, Webster Pearce, Eugene C. Rowe, and John Kelley.

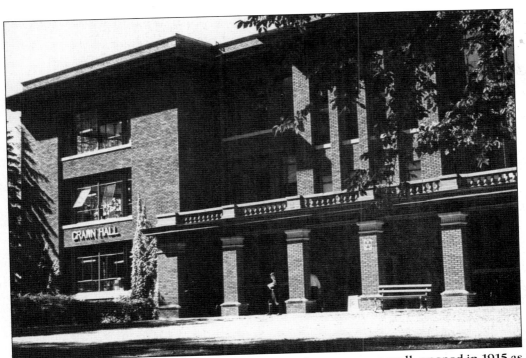

Charles Grawn Hall, on the west side of the Central core campus mall, opened in 1915 as the Science and Agricultural Building (above) and survived two fires (in 1933 and again in 1954) to become the oldest building on campus. Upon opening, the building contained the agriculture, psychology, biology, physics, and chemistry departments and housed the university print shop for a time. In 1965, following addition of a south wing, below, Grawn Hall became home to the business department. The Applied Business Studies Complex, in a south wing of Grawn Hall, was added in 1989 on a site once occupied by a greenhouse attached to the science building. The Applied Business Studies Complex, partially funded by a $400,000 Dow Chemical Company donation, is home to the LaBelle Entrepreneurial Center, named for Mount Pleasant restaurateur Norman LaBelle.

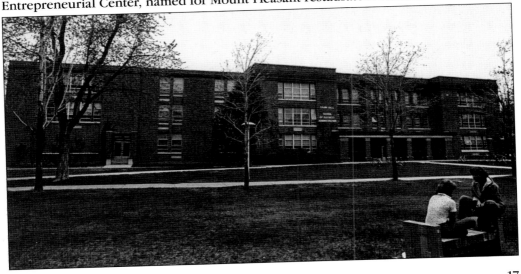

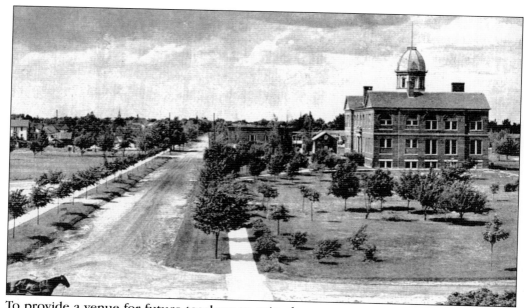

To provide a venue for future teachers to gain classroom experience face to face with actual students, the Central Michigan Normal School constructed the training school building in 1902. This early view of the new building, looking north from the main administration building, shows Normal Street bisecting the campus, downtown in the background, and the H. G. Gover store (see page 113) in the center just beyond the training school.

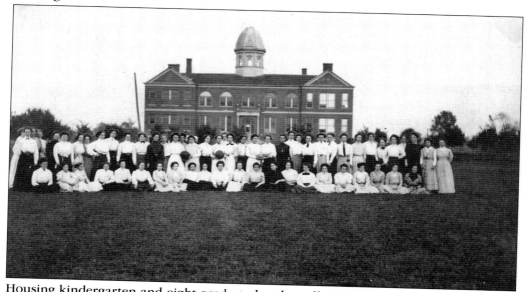

Housing kindergarten and eight grades, plus the college manual arts department, the training school offered teacher education students the opportunity to work with Mount Pleasant children and the offspring of Central faculty. The first Central Michigan Normal School teacher education students to gain experience in the training school building included this assemblage of 1903 graduates. The training school, later College Elementary School, tradition would continue on the Central campus until 1969.

Anna M. Barnard was the 1899–1941 Department of Foreign Languages head. Hailed as having "considerable influence upon the lives of students as well as upon the institution itself" by the campus newspaper in 1947, Barnard honed her language-teaching skills with firsthand experiences gained through travels to many countries of the world, including Denmark, England, France, Germany, Greece, Italy, the Near East, the Scandinavian countries, and Switzerland.

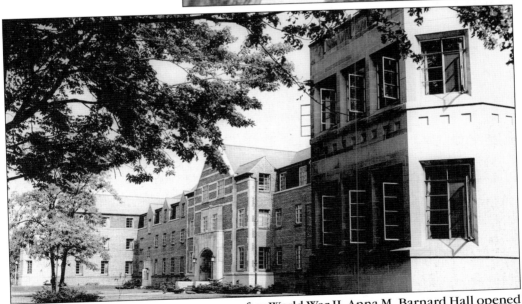

Prompted by demand for more campus after World War II, Anna M. Barnard Hall opened in 1948, the largest dormitory on campus, housing women until 1973, then converting to coed residency until its closing. An adjoining food commons serving Barnard, Sloan, and Ronan Halls had the capacity to seat 600. Along with Tate Hall, Barnard was demolished in 1997 in the face of structural problems, high cost of remodeling, remediations, and low enrollment.

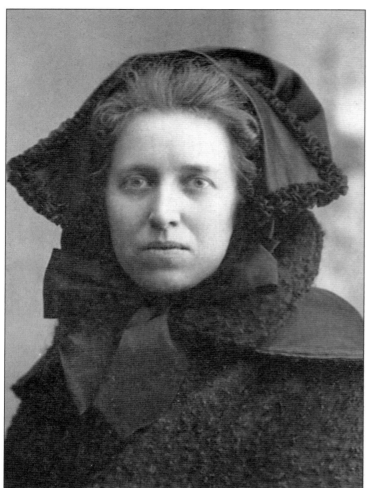

Mae K. Woldt, originally from Urbana, Illinois, headed the biology department from 1906 until 1935. Following undergraduate work at the University of Michigan, she taught at Negaunee High School before coming to Central in 1899. Her graduate work was done at several universities including the University of Heidelberg in Germany, Columbia University, the University of Washington, and Colorado's Rocky Mountain Biological Station.

The Mae K. Woldt Hall was dedicated in 1965 in ceremonies including sister hall, Emmons, seen on page 36. Housing 344 women in 86 suites in a plan like that of Tate Hall, Woldt Hall shared a lobby with Emmons, a campus first. The basement of the Woldt-Emmons complex contained a student union with a cafeteria, bookstore, and recreation rooms downstairs from the dining room in space later occupied by computer services.

Elizabeth Wightman Hall opened in 1948 on the west side of Washington Street at the site of the old athletic field, used until 1930. Initially housing the home economics department, industrial education classes, and the university press print shop on the ground floor, with the Department of Fine Arts on the second, Wightman Hall is now home to the art and human environment studies departments.

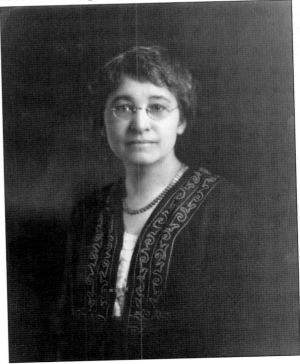

Elizabeth R. Wightman's initial teaching took place in the Mount Pleasant public school system before studying at Ypsilanti Normal College and returning to teach art and geography at Central Michigan Normal. Promoted to the rank of professor and head of the Department of Art in 1900, she was faculty advisor to the art club. Retiring in 1937, she died in a Detroit hospital in 1940 after a short illness.

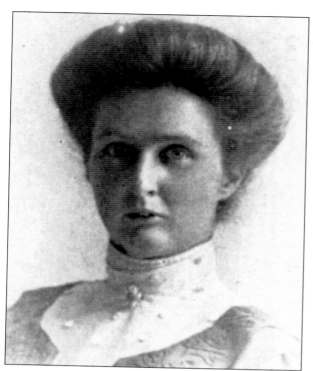

Elizabeth Saxe began as a student assistant at the normal school library in 1901 and retired as assistant librarian in 1946, she was instrumental in the plans for a Mount Pleasant city library in 1910. Following the 1925 Old Main fire that decimated the school's library resources, she worked tirelessly repairing and replacing the loss of books. During her tenure, Central's library increased from 3,000 to 56,000 volumes.

In the east campus complex as part of the unprecedented 1959–1968 Central Michigan University expansion boom, the $1.4 million Elizabeth Saxe Hall, sister hall to Herrig Hall (see page 41), opened in the autumn of 1968 as a men's residence hall and became a coed residence hall in 1970. The occupant capacity of the hall is 344 students.

Central Hall was opened in 1909 as the first gymnasium on campus. World War I soldiers trained in the building, as did World War II naval officers. Following the 1951 completion of Finch Field House, the Central Hall Physical Sciences Building became the Reserve Officer Training Corps (ROTC) building until the early 1970s demolition in the face of an executive decision by Central president William Boyd (see page 97).

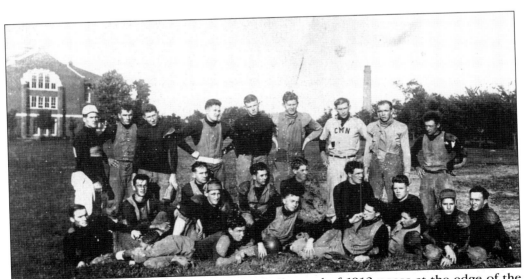

The Central Michigan Normal School football squad of 1912 poses at the edge of the athletic field behind Old Central Hall (the physical sciences building) on the west side of the campus mall, approximately where Wightman Hall, on Washington Street, now stands. In the background is the smokestack of the first campus power plant.

The Central Michigan Normal School campus is depicted in this 1910 postcard view. The normal training school (which burnt in 1933) is shown at the left, with the power plant smokestack in the distance, while the main building (destroyed by fire in 1925) served as administration offices, library, and auditorium and the old Central physical science building completed the base core campus ensemble. The mall at the southern terminus of Normal Street (south of the present University Street terminus at Bellows Street) in Mount Pleasant constituted the entire Central campus when this postcard was created. The next building to be added would be Grawn Hall in 1915; it was located in the area of the right foreground of this view. Grawn Hall, the oldest building on the Central Michigan University campus mall, remains the nucleus of the modern Central Michigan University campus (see page 125).

The first Central faculty member to have a doctorate, Dr. Eugene C. Rowe, came to Central in 1902 to found the Department of Psychology and Education, retiring in 1936. Rowe was the United States Army chief psychological examiner during World War I, helping develop the army alpha test, predecessor of the intelligence quotient (IQ) test. Before his 1946 death, he also helped pioneer the eugenics movement.

Eugene C. Rowe Hall, a teacher education center, opened in 1958, housing the College Elementary School and departments of psychology and education, sociology, economics, and political science. Now home to several university offices and the Center of Cultural and Natural History, Rowe Hall has a Native American Gallery, added to the museum in 1994, begun with a donation by the late Olga and R. G. "Rollie" Denison, Mount Pleasant residents.

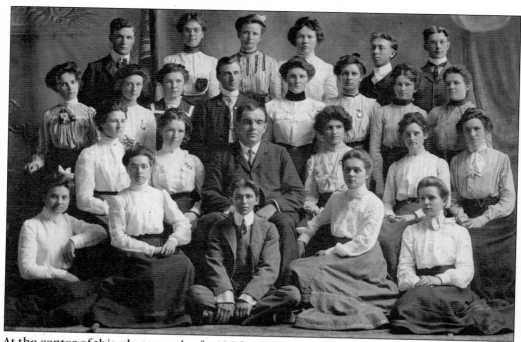

At the center of this photograph of a 1904 rural school graduation photograph featuring early-20th-century Central faculty, R. D. Calkins came to Central Michigan Normal School in 1902, retiring in 1944. Besides teaching at Central, Calkins taught summer sessions at the University of Columbia, University of Chicago, and University of California, Los Angeles. Calkins's wife was active in establishing Mount Pleasant's first city library.

At the north end of campus, west across Washington Street from the campus core mall, the 312-resident R. D. Calkins Residence Hall opened in 1958 as the third segment of the Robinson Hall, page 37, Trout Hall, page 50, and Lazelere Hall, page 40, complex. Originally a dormitory, the hall housed men in 1959 and 1960 before reverting to a women-only residence hall.

Bertha M. Ronan was a physical education professor from 1903 to 1923 and dean of women from 1923 until her 1943 retirement. Ronan held two prestigious positions on campus in different Central eras. She also had two campus buildings, at different times and places, named in her honor. She was further honored with turning the first shovelful of dirt in groundbreaking ceremonies for Central's first Ronan Hall in 1922.

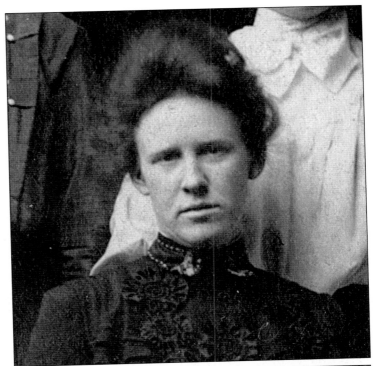

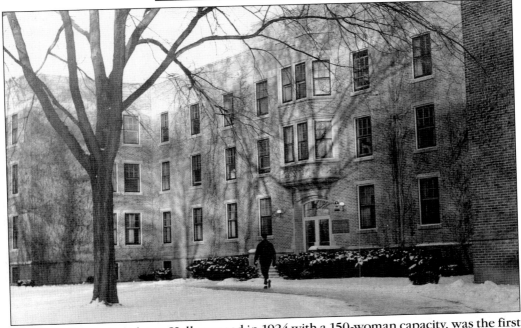

Bertha N. Ronan Residence Hall, opened in 1924 with a 150-woman capacity, was the first residence building on campus, boasting Central's first elevator. The navy's V5 program used the hall as a dormitory and training center during World War II, returning the hall to a women's dormitory in 1945. The building was demolished in 1970, after determination by contractors that it was too old to survive a major renovation.

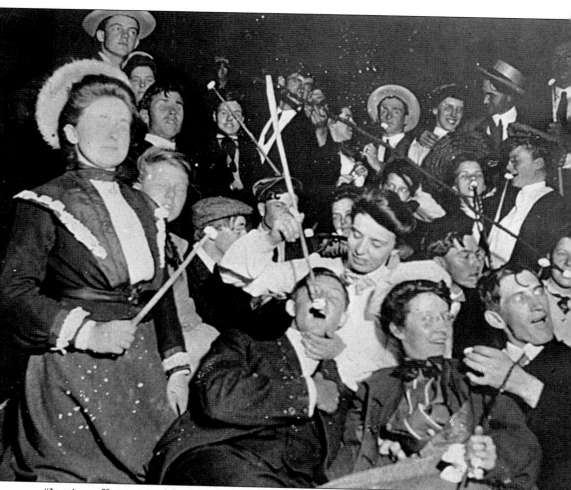

"Letting off steam" in the face of the pressures of collegiate life at Central was not invented in the 1980s and 1990s, despite the beliefs of denizens of those student eras. Buried in the files of Clarke Historical Library, this intriguing photograph has a note on the back written by an A. R. Gilpin, presumably the donor, reading "This is from a marshmallow roast at Strawberry Point on the Chippewa River either in the spring term or summer term of 1906. Archie Gilpin in front with Olive Hafer feeding him. Carl Knirk in the lower right. Lloyd Linrmore in the extreme upper right. Lee Newton near him with arm around girl. Spencer Kelly in upper left. Bob Kennedy with eyes closed." The others are not named, even though Gilpin's note makes the offer to name the rest.

Ira A. Beddow came to Central after teaching at Elm Station in Detroit, West Side School in Bay City, and at Olivet College and had been superintendent of schools at Plymouth. Beddow began teaching history at Central in summer session, joining the faculty as speech instructor in 1906. He headed the Department of Speech and Reading from 1906 to 1939. He directed commencement plays during graduations for a number of years.

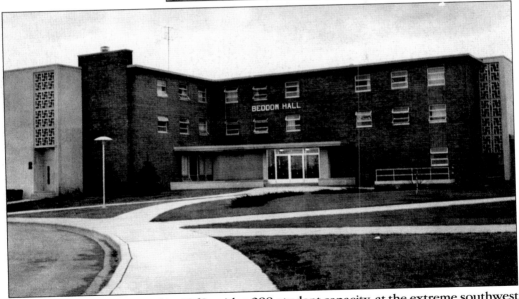

Ira A. Beddow Hall opened in 1962, with a 288-student capacity, at the extreme southwest reaches of the Central campus of the time, facing Broomfield Road overlooking the countryside. Reflecting changes in Central policy, signing in and out was no longer required, the quiet hour policy was loosened, men could visit women's suites, and drinking by residents of legal age was allowed.

29

Respected conservationist and agriculture authority Myron A. Cobb came to Central in 1908, beginning his career at the school teaching chemistry before being named head of the Central Michigan Normal Agriculture Department in 1912 until his 1936 death in an automobile accident. Cobb planted a number of forests statewide, for which he was honored by having a wildlife refuge named for him by the State of Michigan.

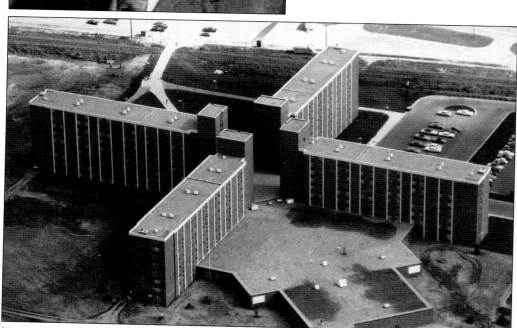

Myron A. Cobb Residence Hall, a 415-resident wing of the complex west of Washington Street at Broomfield Road in the southwest campus known as the Towers (page 32), opened in the winter of 1970 as a residence hall for women but was converted to a coed living facility in 1973. Cobb Hall was the last of the four residence halls comprising the Towers to open.

30

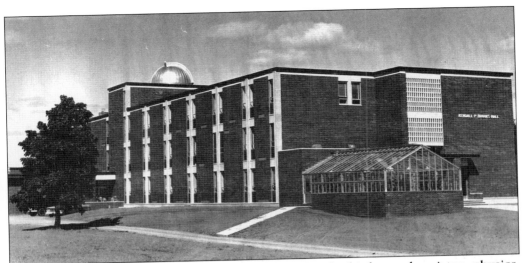

Kenneth P. Brooks Hall became headquarters for the biology, chemistry, physics, mathematics, and physical sciences departments when those moved from Grawn Hall and the business department moved to Grawn Hall. Opened in 1963, Brooks Hall was the largest building on the Central Michigan University campus, the first classroom building completed since Rowe Hall in 1958. The hall was remodeled in 1970 with help from a Herbert and Grace Dow Foundation grant.

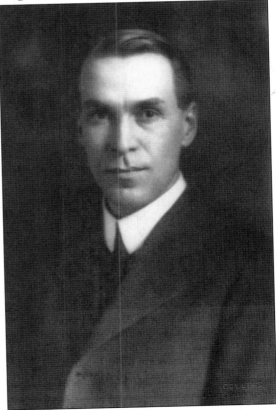

The son of a Baptist minister who was also president of Kalamazoo College, Brooks was superintendent of Marquette schools before resigning in 1908 to spend two years studying physics in Germany. He came to Central in 1910 to head the physics and chemistry department. Brooks was also registrar of the school and the director of Mount Pleasant's Exchange Savings Bank during the Great Depression.

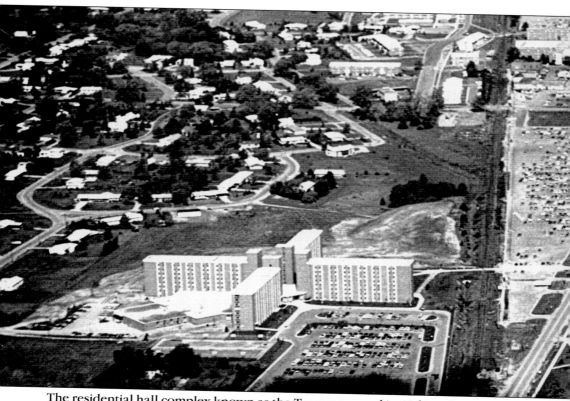

The residential hall complex known as the Towers opened in 1969 and 1970 on property newly annexed to Central Michigan University near the intersection of Washington Street and Broomfield Road southwest of the campus core mall with four nine-story "arms." The Towers is comprised of Carey Hall (page 44), Cobb Hall (page 30), and Troutman and Wheeler Halls (facing page). Partially based on blueprints designed by students in the mid-1960s, the 1,400-resident Towers were originally planned for the north end of the Central Michigan University campus on the current Northwest Apartment location. The locale of the project was shifted south following engineering findings that the initial site's ground lacked the stability needed to support the huge buildings. Union Township's 1968 refusal to extend water and sewer services brought construction to a stop while the issue could be resolved. Some halls opened as men's and some as women's residence halls, but all of the Towers are currently coed.

Oliver W. Troutman was named head of Central's manual training department in 1913 and served in that position until his 1933 death after a short illness. Troutman added a number of courses to the Central Michigan Normal School curriculum, including metalworking. Troutman's namesake 336-resident Troutman Residence Hall arm of the Towers, on the facing page, opened in 1969 as the first in the complex to be completed.

The 416-resident George R. Wheeler Residence Hall arm of the Towers complex, facing page, is named for the 1947–1960 head of Central's Department of Conservation and Agriculture. An Isabella County resident, Wheeler, in addition to teaching, was an Isabella County State Bank director, a director of Central Michigan Community Hospital, and lieutenant governor of the Michigan Kiwanis and was voted Mount Pleasant Outstanding Citizen of the Year in 1968.

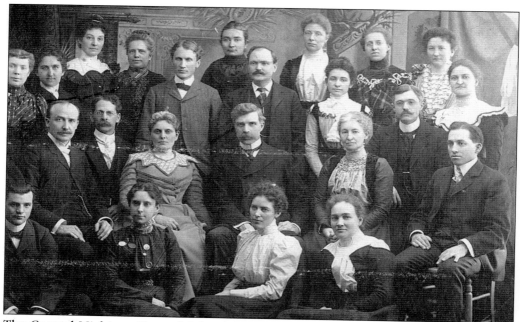

The Central Michigan Normal School faculty, above, appears to reflect the youth and vitality of the fledgling institution of learning they serve when captured by the camera in the early 1900s. From left to right are (standing) Gertrude Robinson, Mary Jane Jordon, Estelle Whitten, Margaret Wakelee, Charles F. Tambling, Gertrude Dobson, George W. Loomis, Carrie Simpson, Elizabeth R. Wightman, Mae K. Woldt, and Lois and Anna M. Barnard; (seated in chairs) John Kelley, William Bellis, Lucy Adella Sloan, principal Charles McKenny, Rachel Tate, Carl Pray, and Fred L. Keeler; (seated on the floor) T. Bath Glasson, Bertha I. Howe, Irene Getty, and Myrta Wilsey. A part of the exuberance of life at the young school can be seen below at a 1915 Valentine's Day party.

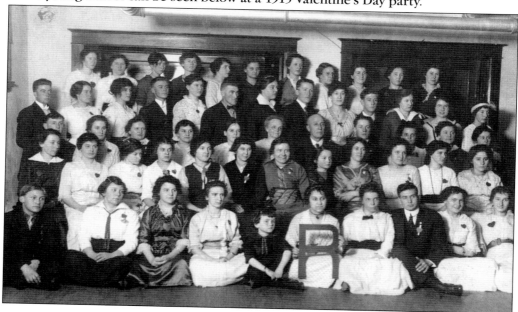

Webster Houston Pearce had been principal of Albion (1905–1908) and Adrian (1909–1916) High Schools and taught at Michigan State Normal School before becoming a mathematics professor at Central. He was mayor of Mount Pleasant from 1921 until June 1927 and was superintendent of public instruction for two terms. Pearce was appointed Northern State Teachers College president in 1927 and died at his Marquette home in 1940.

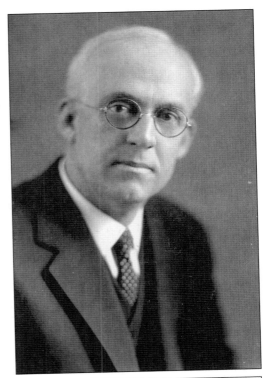

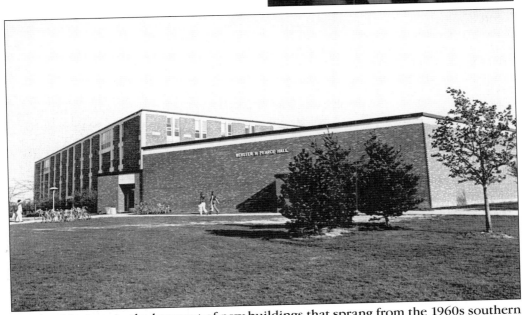

Another blossom in the bouquet of new buildings that sprang from the 1960s southern expansion of Central Michigan University into newly annexed land between Preston Street and Broomfield Road, Webster Houston Pearce Hall opened in 1967, one of a three-building classroom complex including Brooks and Anspach Halls. Housing the foreign language and mathematics departments when opened, Pearce Hall is now home of the mathematics and computer sciences departments.

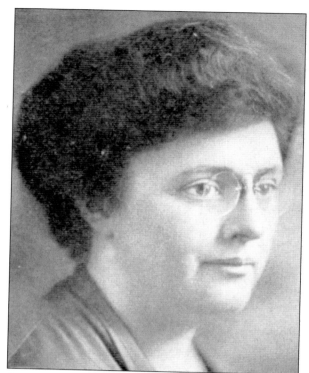

Helen R. Emmons, who received her lifetime teaching certificate from the Chicago College of Education and taught kindergarten in South Dakota before coming to Central Michigan Normal School in 1916, was the school's Department of Early Education head from 1926 until 1934. She was a large influence in helping to establish kindergartens in Michigan school systems.

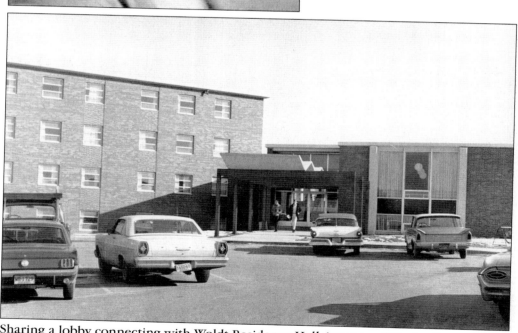

Sharing a lobby connecting with Woldt Residence Hall (see page 20), the first complex of its kind on campus, the 344-resident Helen R. Emmons Hall opened in 1965. The basement of the Woldt-Emmons complex contained a student union with a cafeteria, a bookstore, recreation rooms, and, in the 1980s, an art studio beneath the dining room in space later occupied by computer services.

Frank E. Robinson never graduated from high school but passed his teaching examination at Ferris Institute, attended Central from 1903 to 1905, earned his life teaching certificate, earned his master of arts degree at the University of Michigan, and taught at Bronson. He returned to teach at Central in 1911 and was head of Central's Department of Commerce from 1916 until 1948, when state law required his retirement at age 70.

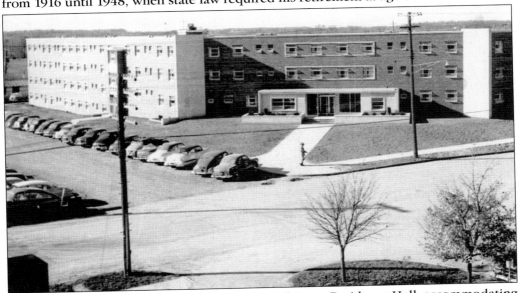

A first on campus and in the nation, Frank E. Robinson Residence Hall, accommodating 250 residents in 123 suites with an individual bathroom in each suite, rather than the single rooms with a community bathroom that were the previous hall norm, opened in 1954. Housing men from 1954 to 1959 and women from 1959 to 1960, then men again 1961 to 1988, Robinson was finally converted to coed housing.

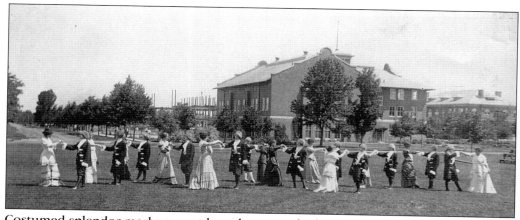

Costumed splendor marks an outdoor dance on the lawn just west of the core campus mall in 1914. The training school building, right, has shed its turret and buttresses while the physical sciences building, center, is aglow with newness. Grawn Hall is taking shape in the background, readying for its April 1915 opening, and the tree-lined dirt road, left, was the south terminus of Washington Street. The Central Michigan Normal School ROTC band, below, strikes a chilly chord at a practice session during the winter of 1916–1917. Grawn Hall is now complete, and the upper left provides a glimpse of nearby homes along Main Street.

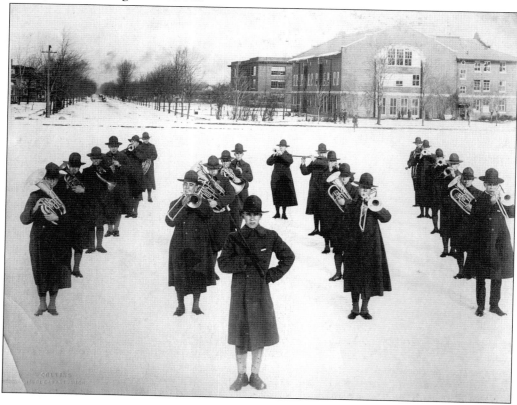

Two

THE WARRINER PRESIDENTIAL ERA 1918–1939

Dr. Eugene Clarence Warriner was elected the second president of Central Michigan Normal College by the Michigan Board of Education. A licensed Methodist Episcopal minister and devoted sports fan, Warriner had pursued graduate degrees at Clarke, Harvard, and Columbia Universities. An advocate of temperance and the peace movement during World War I, Warriner had a 21-year tenure as president and saw an influenza epidemic in 1918, two devastating campus fires, the beginning of bachelor of arts and graduate course offerings at Central, and the Great Depression. The state's first women's dormitory for a normal school campus and a new athletic field were constructed and Central was renamed Central State Teachers College during the Warriner presidential era.

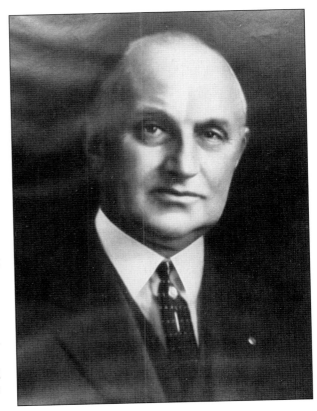

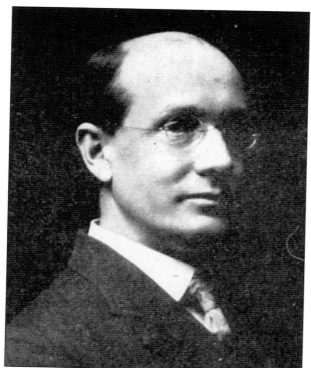

Claude S. Lazelere headed Central's Department of History and Social Studies from 1900 to 1939. He authored numerous Michigan history and government books and articles. Lazelere came to Central after receiving a bachelor of literature degree from the University of Michigan, doing graduate studies at the University of Chicago and Oxford University, earning his master of arts degree at Harvard, and serving as school superintendent in Lowell, Michigan, and Jefferson, Ohio. He died in 1946.

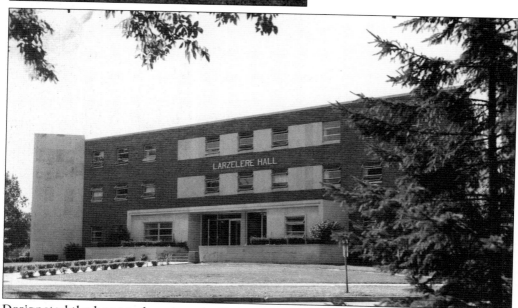

Designated the honors dormitory in 1972, Claude S. Lazelere Residence Hall opened in 1957 as a 312-resident men's dormitory, with the outside copied from Robinson Hall, inside copied from the suite plan of Tate Hall. Lazelere shares dining commons with Robinson, Calkins, and Trout Halls at the northern campus perimeter near the intersection of Washington and Bellows Streets. A women's dormitory from 1959 to 1970, Lazelere Hall was converted to coed residency.

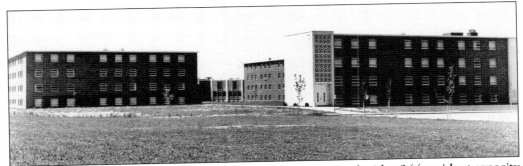

Anna B. Herrig Residence Hall, sister hall of Saxe Hall, opened with a 344-resident capacity in 1966 and was dedicated on the 75th anniversary of Central Michigan Normal School and Business Institute's founding on December 10, 1967. At the dedication ceremony, Roger Allen of Grand Rapids' Roger Allen Associates, designer of many Central buildings, received an award for service to the university. A women's dormitory, Herrig converted to coed residency in 1970.

The first woman in the United States to receive the new certificate to teach at normal schools, Anna B. Herrig was principal of teacher training schools in South Dakota and Nebraska, besides teaching in New Paltz, New York. At Central, she was assistant professor of psychology and education from 1921 to 1938. She started a World Acquaintance Tour, a Negro Acquaintance Tour, and an annual breakfast at the Indian School in Mount Pleasant.

Ernest J. Merrill of Grand Blanc was the son of a farmer and teacher. Graduating from Flint High School and Albion College, Merrill taught at two Michigan schools. He was then a chemist for Republic Truck Company in Alma, joining the faculty at Central in 1921 to head the Department of Physics and Chemistry until 1953, when he retired. Merrill was advisor for the school's Young Man's Christian Association (YMCA).

First Ernest J. Merrill Residence Hall student residents endured some hardship due to the distance to the rest of the campus when the hall opened in 1960 near the extreme south end of the Central Michigan University campus; Warriner Hall was then the closest classroom building. By the end of the 1960s, the 388 residents of Merrill Hall found themselves in the center of things as the campus grew to meet them.

Joseph P. Carey spent his life serving the school known as Central Michigan Normal School, Central State Teachers College, Central Michigan College of Education, Central Michigan College, and Central Michigan University, as well as his community. Carey, who was head of Central's geography department from 1944 to 1956, joined the school's faculty as assistant professor of geography in 1925, the year Michigan became a commercial oil-producing state. The discovery of the Mount Pleasant oil field in 1928 shielded the town, and to some degree Central, from the financial devastation of the Great Depression. Carey, president of the Mount Pleasant Board of Education and chair of the city planning commission, also served as secretary of the Michigan Oil and Gas Exposition Committee. The exposition brought more than 30,000 people to the town's Island Park in 1935, with an opening parade, below, led by a hearse bearing an effigy of "Ole Man Depression." The Joseph P. Carey Residence Hall opened in 1970, the second building in the Towers (see page 32) and the first coed residence hall on campus. Carey chaired the faculty athletic committee for 20 years.

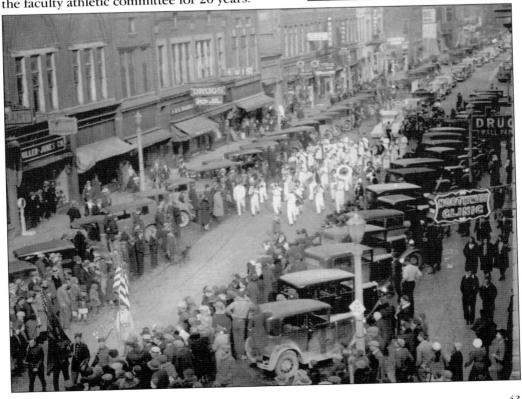

Daniel P. "Call me Dan" Rose, a basketball star when he graduated from the University of Michigan, came to Central in 1937 to coach basketball and baseball. He became Central's athletic director in 1942, serving in that position until 1972, a total of 30 years. He died in Mount Pleasant at age 95 in 2003.

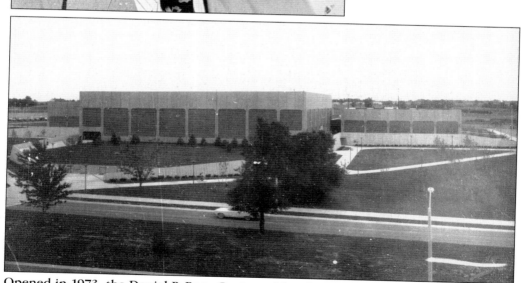

Opened in 1973, the Daniel P. Rose Center, with a 5,200-seat arena, is the site of all of Central Michigan University's home basketball games and volleyball matches, played on a wooden court purchased by Central after having been used only once, for the 1986 National Basketball Association (NBA) All-Star game. Rose Arena has hosted a number of major sports events including both women's and men's championship contests.

Grace L. Ryan, an expert published on the subject of American folk dances, joined the Central faculty in 1923 as a teacher and authority in health and physical education. During her 31-year Central career, she added a recreation minor to the curriculum of the physical education department in 1937 and launched a folk dance school in 1942. Ryan was nationally known as a consultant for college physical education programs.

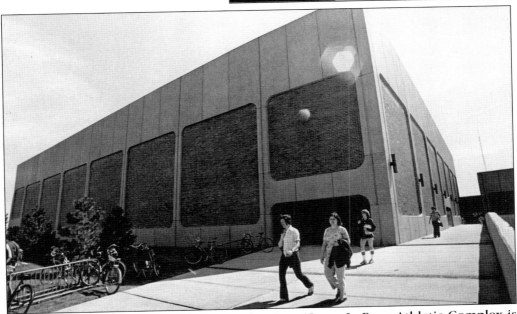

The Grace A. Ryan Studio in the Daniel P. Rose/Grace L. Ryan Athletic Complex is used fully for large classes and small performances. The respected Orchesis Dance Theatre dance company, featuring 30 to 40 talented university students in professionally choreographed jazz, ballet, contemporary, and ethnic dances, performs at Ryan Studio, among other campus venues, in the fall and spring semesters and once annually as part of the University Theatre series.

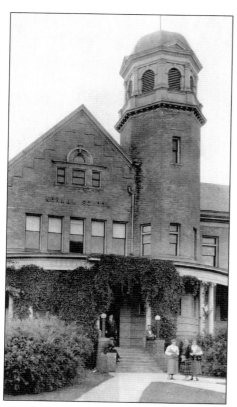

Central Michigan Normal School students and faculty at the front entrance of Central Michigan Normal School's main building in the spring of 1925 were more fascinated with the camera than in their academic pursuits of the day. By the end of the year, the oldest structure on campus (built in 1892) would succumb to a fiery demise.

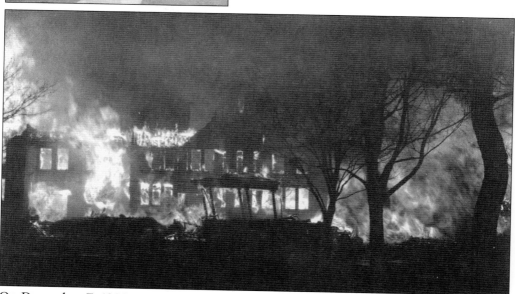

On December 7, 1925, citizens of Mount Pleasant awoke to the sounds of chaos as the main office and 30,000-volume library housed in the Old Main building of Central Michigan Normal School disappeared in a wall of flame dancing into the early morning sky. Temporary buildings were erected on the campus mall to house classes, and work immediately began on a new administration building, Warriner Hall.

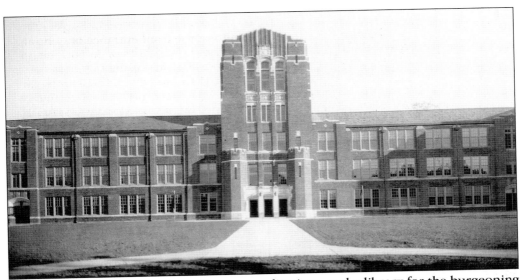

Providing new administration offices, an auditorium, and a library for the burgeoning Central State Teachers College, Warriner Hall, above at completion (note the lack of trees), was named for college president Eugene E. Warriner and dedicated on June 17, 1928, replacing Old Main, the school's first building. Warriner Hall, below and on the cover, remains the most enduring symbol of Central today. Warriner predicted at the hall's opening ceremonies, "While we have made many changes in the past few years, we feel we have only begun to develop and to grow." This book offers evidence of the Warriner prognostication.

Lawrence M. "Doc" Sweeny came to teach at Central in 1939 and in his 27-year career coached nearly every sport at Central: football 1939–1952, basketball during 1944 and 1945, and baseball during 1945. He was also head coach of the gymnastics team he started in 1939 until his 1966 retirement. He also trained students majoring in physical education and was instrumental in the change in name for Central athletic teams from Bearcats to Chippewas.

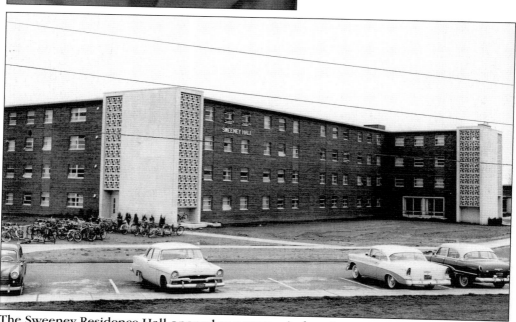

The Sweeney Residence Hall opened as a women's dormitory, sister hall of Merrill Hall (see page 42) near Preston Road in the then remote outer southern reaches of the 1961 Central Michigan University campus. Sweeney Residence Hall has a 318-resident capacity and was converted to coed residency in 1970. Within the decade, Sweeny and Merrill Halls were surrounded by academic and residence buildings.

Judson Foust attended Albion College, where he received a degree in 1923. After teaching mathematics in a Lansing high school while earning a master's degree in 1927, Foust joined the faculty of Central State Teachers College as a mathematics instructor in 1929, earning his doctorate in 1938 and authoring a number of textbooks. For more information about Judson Foust and his Central Michigan University presidency, see page 84.

Originally planner as a hospital, Judson Foust Hall was opened in 1973 and is a multipurpose building of modern design and cast concrete outer construction. Foust Hall houses a host of programs and departments, including academic assistance programs, a counseling center, a master of science in administration program, an office of graduate studies, an office of research and sponsored programs, student disability services, and university health services.

David M. Trout joined the faculty in 1937, serving as head of the Central State Teachers College Department of Psychology and Education before becoming dean of students until his death in 1954. Trout started the Division of Student Personnel and advised the Student Personnel Association for Teacher Education. The David M. Trout Residence Hall opened in the fall of 1959 with a 296-student capacity, housing men for its first year and women in the fall of 1960. Trout Hall is part of the complex at the north campus containing Calkins, Lazelere, and Robinson Halls. During and after the Korean War, Trout Hall was the base of operations for a project supporting an orphanage in Munsan, South Korea. Central was the only college in the United States to take on such a program.

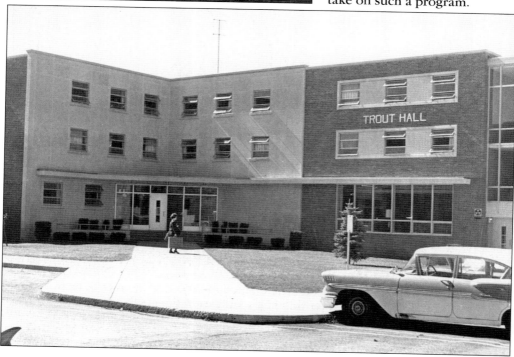

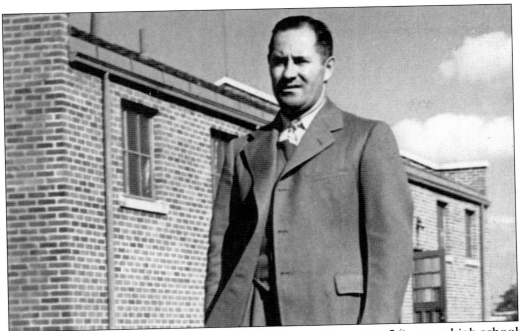

Ronald W. Finch, here in front of the "old field house" (see page 54), was a high school teacher for 12 years before coming to Central Michigan College in 1937. He served as the head track and football coach until 1946 and headed the physical education department from 1942 until 1959. Finch became the first dean of the College of Health, Physical Education and Recreation when that college was formed in 1959.

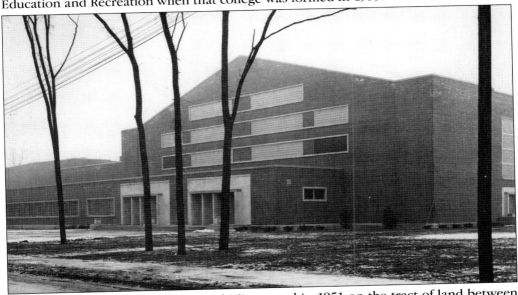

Finch Field House (see pages 72 and 73) opened in 1951 on the tract of land between Alumni Athletic Field and Warriner Hall just southeast of the north campus mall core. At the time of its construction, Finch Field House was the largest building on campus and the second-largest gymnasium in the state. The field house was the main athletic building on campus until construction of the Rose/Ryan Hall and the student activity center.

Charles C. Barnes had a varied career before joining the Central faculty. Following high school graduation, Barnes taught for four years, went to Ferris Institute where he received a finance and commerce degree in 1911, and from 1912 to 1920 was a faculty member and principal of the school of business at Ferris. He resigned to become assistant treasurer of a Detroit life insurance company, returning to education later in 1920 at Central, where he was made the first dean of men. Charles C. Barnes Hall started in 1939 as Central's first men's dormitory, a wing of the Keeler Union (now known as Powers Hall). In 1942–1944, part of the hall was occupied by United States Navy V-12 cadets training at Central during World War II. Expanded in 1951 and again in 1957, the hall was officially named Charles C. Barnes Hall in 1952.

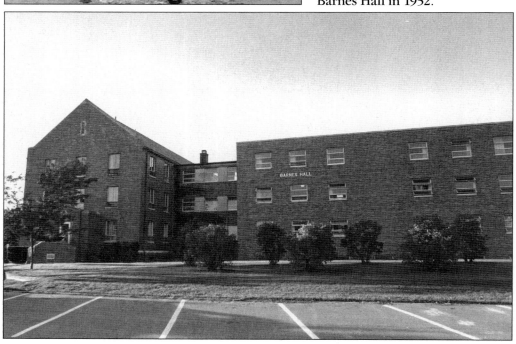

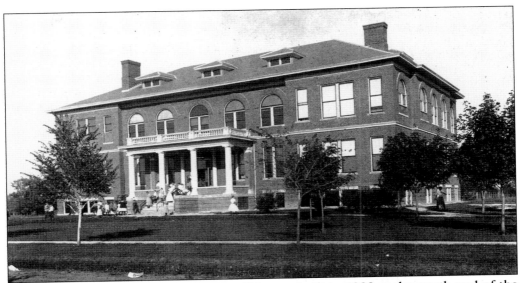

The training school, shown above in 1932, was built in 1902 at the north end of the campus on land initially purchased by the Mount Pleasant Improvement Company and was constructed to accommodate up to 300 students (see page 18). The City of Mount Pleasant agreed to furnish grade-school level students who, along with the children of Central faculty, provided prospective teachers with direct experience in teaching kindergarten through eighth grades. On January 10, 1933, fire consumed the training school, taking with it more than 5,000 books. The building known for a time as North Hall replaced the training school, home to grade-school students until College Elementary School operations moved to Rowe Hall in 1958.

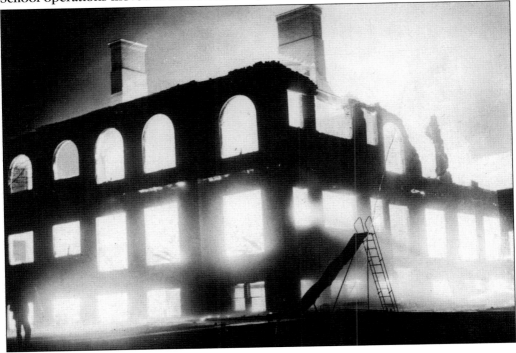

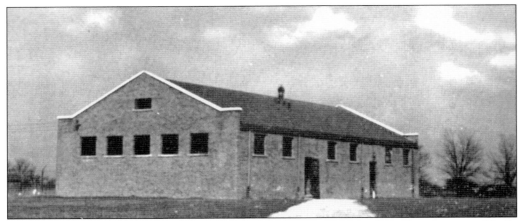

A major growth step for Central athletics was taken in 1930, when the Alumni Athletic Field opened just east of Warriner Hall, below, and saw a shift of football and track events from the old field behind Old Central Hall at the south terminus of Washington Street. The new facility featured a then state-of-the-art field house, above, and acted as host not only to Central athletic events but those of Mount Pleasant High School's Oilers athletic team games and meets as well. The Alumni Athletic Field served college and town alike until the 1960s, construction of the community-financed Carlo Barberi Memorial Field behind the new Mount Pleasant High School, followed by the opening of Kelly-Shorts Stadium in 1971.

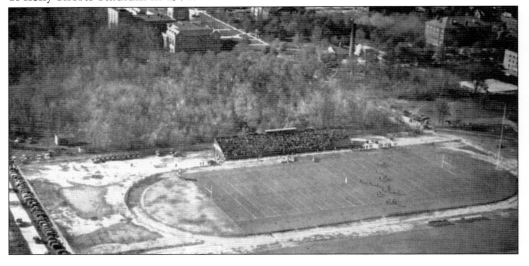

Three

THE AGE OF CHARLES ANSPACH 1939–1959

Charles LeRoy Anspach became
the fifth executive head (the
third president) of the school
then known as Central State
Teachers College in 1939, serving
in that position until his 1959
retirement. Anspach came from
the automotive parts industry in
his youth to be educated through
the masters of arts level at Ashland
College, now university, in Ohio
and earned his doctorate at the
University of Michigan in 1930.
He was registrar, then dean of the
college at Ashland through 1926,
then became head of the education
department at Michigan State
Normal College, Ypsilanti, (now
Eastern Michigan University). In
1935, Anspach returned to Ashland
as president of the college until
1939. He authored three books
and coauthored two books besides
being known as an outstanding
speaker in great demand.

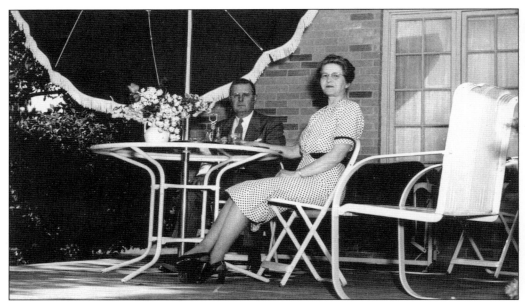

College president Charles LeRoy Anspach was the first Central president to occupy the house on Bellows Street purchased by the college in 1944 to be the home of Central's chief executive. Anspach and his wife, Mary, enjoyed the patio at the residence, hosting many visitors there during their 15-year occupancy. The house would be occupied by the next three Central presidents before becoming the Carlin Alumni House in 1989.

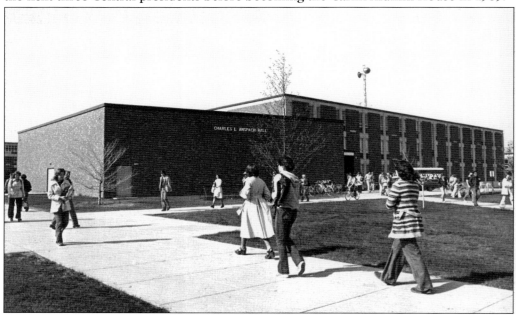

Charles L. Anspach Hall opened in 1966 as a social sciences building, originally housing the sociology, English, history, and political sciences departments, in addition to housing the philosophy department, when organized in 1966, and WCMU-TV, along its way from the "sheep sheds" to the television broadcasting studios on Preston Road in the building that serves also as the university's welcome center, see page 65.

Originally from Waco, Nebraska, Jesse B. Thorpe, right, earned his bachelor of arts degree from Peru Teacher's College in Indiana and his master of arts degrees from the University of Michigan, where he also did course work toward his doctorate. He came to Central as an assistant librarian in 1941 and became head librarian in 1955, a position in which he served until his 1958 death. The Jesse B. Thorpe Residence Hall, below, opened in 1963 along Broomfield Road at the then remote southernmost reaches of the Central campus, with a capacity of 316 residents and a suite format copied after Tate Hall. Always a men's residence hall, Thorpe's location was so remote the first residents were 300 so-called volunteers, randomly selected from the resident population of Ronan, Barnes, and Robinson Halls.

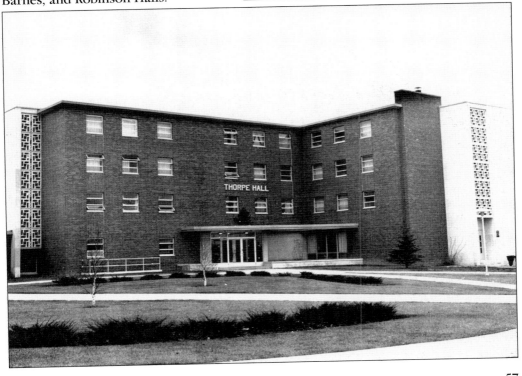

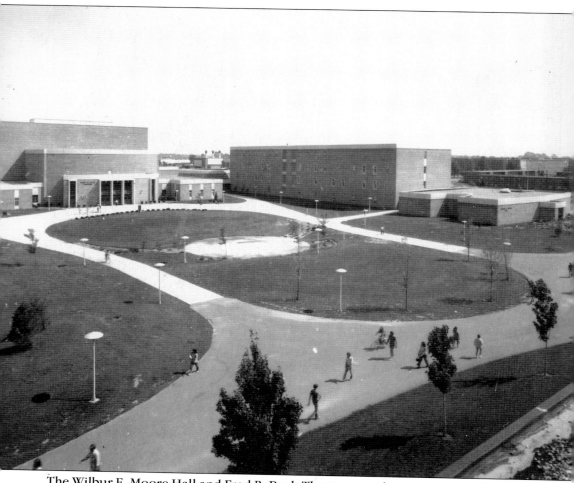

The Wilbur E. Moore Hall and Fred R. Bush Theater complex, servicing and housing the Department of Speech Communication and Dramatic Arts, was opened in the spring of 1971 and was reduced in size by 20 percent from the originally intended size owing to legislative cuts in the building budget. Those budget cuts also affected the radio and television stations that were to occupy the buildings, originally designed to meet classroom needs far into the future, but they were filled to capacity at the time of opening. The complex is located just west of East Campus Drive in the eastern segment of the Central campus. Wilbur E. Moore Hall houses the School of Broadcasting and Cinematic Arts. The Bush Theater offers a live performance venue for both Central Michigan University and general communities. The two buildings are connected by the Kiva, a connecting passage that at first had horrendous acoustic problems and was plagued by echoes until a remedial action was performed in November 1971.

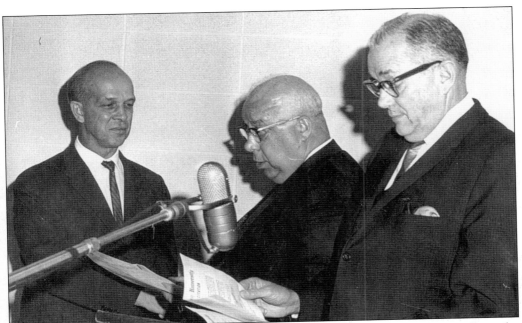

Dr. Wilbur E. Moore (right with Richard Wysong, left, and Judson Foust) taught at the University of Colorado, Kent State, and the University of Iowa before joining the faculty at Central. During his 30-year Central career he served as head of the speech and drama department from 1939 to 1947, Clinical Services Division director from 1947 to 1956, dean of psychology and educational services from 1956 to 1959, and vice president of academic affairs from 1959 to 1970.

Fred R. Bush was a member of Central's English department faculty for many years before joining the speech department on a part-time basis in 1940 to assist in developing the theater program. He directed many plays from then until his 1964 death. Bush and Moore's dynamics brought about an increase to 20 speech and drama course offerings in 1940, from 14 course offerings in 1939.

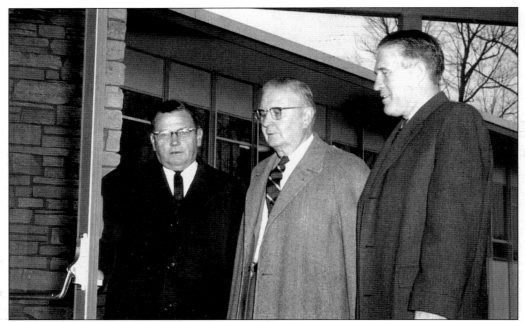

Woodward C. Smith (left), here with Charles Anspach (center) and Michigan governor George Romney, joined Central in 1942 after receiving his bachelor of arts degree from Michigan State University and teaching high school in Remus, Trufant, Nashville, and Comstock Park. An instructor, associate professor, assistant director of extension, and vice president of public services, Smith is credited with growth of the school's outreach programs, precursors of today's College of Extended Learning.

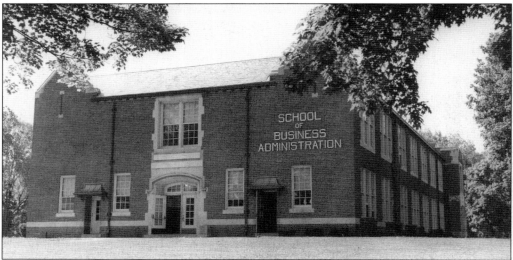

The College Elementary School was built on the east side of the core campus mall, where the original training school was destroyed by fire in 1933. The current Woodward C. Smith Hall was North Hall, housing the business administration department after the 1958 elementary school move to Rowe Hall. The building became Woodward C. Smith Hall in 1984 and houses the management and law and marketing departments and hospitality services administration department.

Leslie (Les) and Margot (Marge) Carlin, a husband and wife counseling team, joined Central in 1948. Leslie worked as a counselor in the Central Counseling Center until 1981, while Marge served as a residence hall housemother until 1967. The Carlin Alumni House, one of only two campus buildings named for a married couple, was built in 1941 as a private residence and purchased by Central in 1944 to house the university's president. College presidents Charles Anspach, Judson Foust, William Boyd, and Harold Abel each lived in the house full time during their presidential years, and college president Arthur Ellis lived there briefly after a 1986 flood. The house was converted to an alumni center in 1990 (see page 115), with a wing containing a conference room, a reception room, staff offices, and workrooms added to the structure.

Central's Civilian Pilot Training Program began in 1939. Escanaba native Don Peltier, above, a pioneer pilot who received flight training through a United States government program, trained the students at the Mount Pleasant airport, below, one of the few in Michigan adequate for the training. Peltier, recipient of the Department of Transportation Federal Aviation Administration Wright Brothers Master Pilot, recalls that students went to classes in the morning and flight training in the afternoon. The first student in the program to solo, on January 10, 1940, was Mount Pleasant's Lucille Davidson. Later U.S. Navy V cadets were housed at Central from 1942 until 1944 while receiving basic military and Peltier-instructed flying techniques training. The V plan of enlistment was open to physically qualified 17-to-20-year-old students, requiring those students to take courses directed by the U.S. Navy.

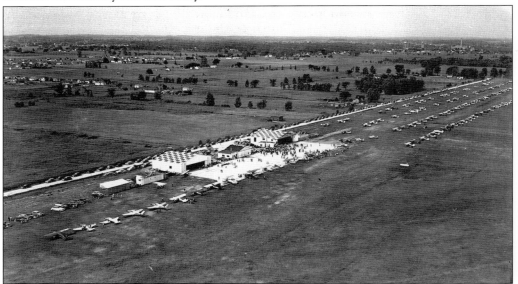

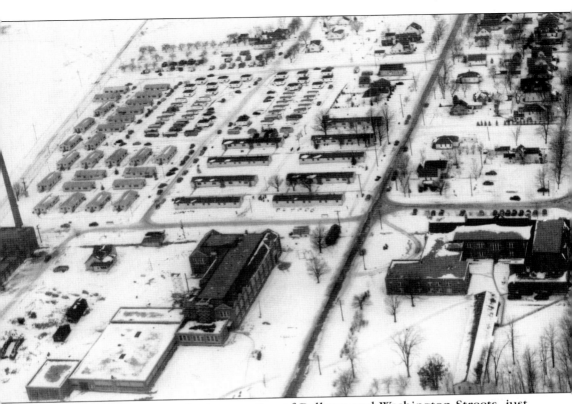

Northeast of campus near the intersection of Bellows and Washington Streets, just north of Wightman Hall, was the site of the temporary buildings known colloquially as the "sheep sheds." Some had been built as temporary classrooms following the 1925 destruction by fire of the main administration building and were used again after the 1933 training school fire. The sheep shed compound expanded greatly in the aftermath of World War II, when a wave of veterans came to Central and were in need of housing. First, 35 trailers were moved into the area, and more housing was built for returning veterans and their families. The field house at Alumni Athletic Field was converted to a bunkhouse for 50 men, and the college appealed to townspeople to make rooming space available to the wave of incoming students. Later the "Vetville" buildings were converted to offices and gradually phased out in the 1950s and 1960s campus building booms as the campus expanded.

The Central Michigan College of Education enrollment of freshman male students in 1946 swelled to almost twice the enrollment numbers of women, with more than half of that year's freshman enrollment made up of World War II veterans. Barracks-type structures were built next to the trailer court near Washington Street, with those living there feeling lucky to have found a home.

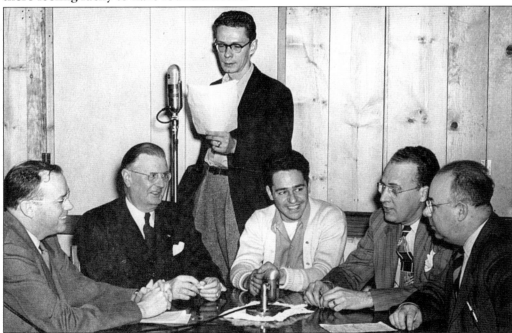

The first broadcast of the Central Michigan College of Education public radio station was made on January 10, 1951. Announcer Grant Little stands at the microphone while a roundtable discussion ensues between (from left to right) speech department head Dr. Wilbur Moore, Central's president Dr. Charles Anspach, student council president Warren Searly, Central's chief financial officer Norvall Bovee, and Central vice president Dr. Judson Foust.

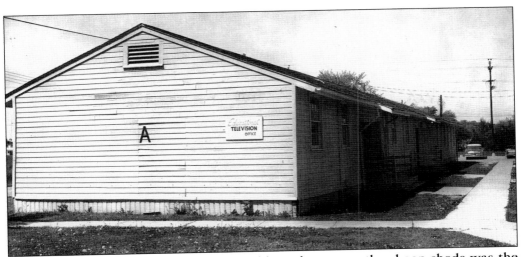

Among many office residents of the buildings known as the sheep sheds was the educational television office (above), the first outpost of what would become a giant communications medium. Educational television offices moved to the library basement, then to Anspach Hall for a time, then to the current home on Broomfield Road near the intersection with Mission Street in the 1980s, below. The building also houses the Central Michigan University Welcome Center. Now the largest university-owned public broadcasting network in the nation, with six television and seven radio stations, Central Michigan University Public Broadcasting reaches more than two million residents in a coverage area that includes at least 52 counties in central and northern Michigan and portions of Ontario. This outreach enhances the university's mission to provide vital information, entertainment, and educational resources to both a large geographical area and underserved communities.

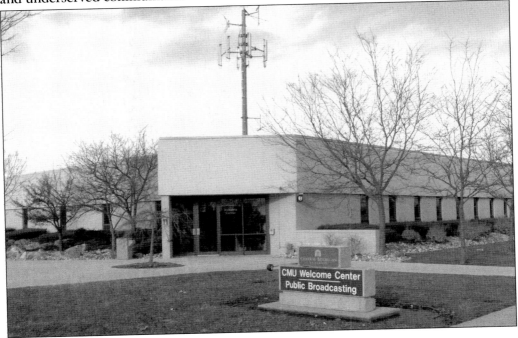

Central Michigan Life, the student newspaper of Central Michigan University, traces its roots to 1902, when the *Central State Normal News* appeared as a monthly pamphlet and became the monthly *Central State Normal Bulletin* sometime before World War I. After that war ended, Central English language instructor Harry Miller returned to campus from the army envisioning a weekly newspaper for the school. Miller put the first issue of *Normal* on the streets on December 2, 1919. The tabloid-sized paper, written mostly by faculty, survived almost solely on advertising revenues. During the 1950s, above, *Central Michigan Life*, the student-written weekly, worked out of offices in the temporary buildings in Vetville. Today *Central Michigan Life* is a broadsheet student-operated newspaper, operating from offices in Moore Hall, below, and is printed three times a week, independent from the university with only the adviser and executive secretary salaries paid by the university. The balance of expenses are met by advertising revenue, with publication circulation of more than 13,000, distributed to select university buildings and several Mount Pleasant community businesses.

Kenneth A. "Wild Bill" Kelly, right, won nine varsity letters while a student at Mount Pleasant High School in basketball, football, tennis, and track. As a Central student he won 13 letters. After his 1930 Central graduation he coached at Cass City High School for eight years, Mount Pleasant High School for four years, and Arthur Hill High School for nine years before joining Central Michigan College in 1951, where he coached the Central Chippewa football teams to a 91-58-2 record before his 1966 retirement. Kelly-Shorts Stadium opened in 1971 named only Shorts Stadium after a 1900 Central graduate, Saginaw banker Perry Shorts. The Central Michigan University Board of Trustees renamed the 30,199-capacity stadium Kelly-Shorts Stadium in 1983 to honor longtime football coach Kelly.

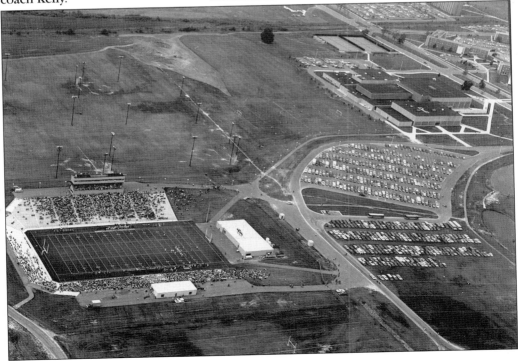

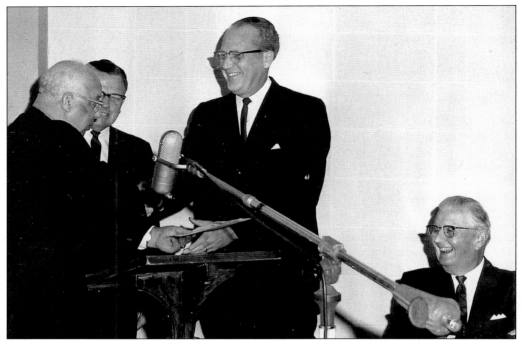

Norvall C. Bovee, above at the podium (center) with Judson Foust (far left), Woodward C. Smith, and Charles Anspach (seated), was a member of Central's administration for 30 years, coming to the school in 1940 from Eastern Michigan University to direct Keeler Union (currently Powers Hall). Appointed Central Michigan College of Education business manager in 1946, Bovee became vice president of business and finance in 1956, holding that position until his 1970 death.

The student center at Central Michigan University was built with the assistance of Central alumni and opened in October 1960. In 1984, the center was dedicated as the Bovee University Center in honor of Norvall C. Bovee. The university center today houses student service offices; retail operations such as the Central Michigan University Book Store, restaurants, and many student organizations; and provides meeting rooms for lectures, discussion, conferences, and social activities for both the university and the community.

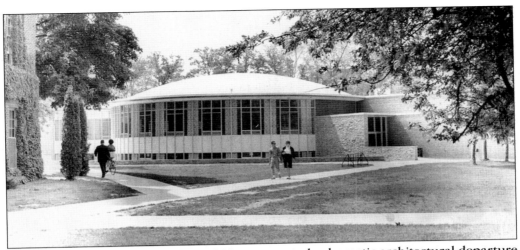

The student center, when built in 1959, represented a dramatic architectural departure from the standard brick and mortar construction and offered a contrast between the student center and the ivy-clad walls of Warriner Hall, above left, and other preceding Central Michigan University buildings. Replacing Keeler Union, the building that would become the Bovee University Center featured a 12-lane bowling alley, a book/newspaper browsing area, a barbershop, a newsstand, a tobacco shop, and two dining rooms. The center, along with the A-frame chapel beside it, page 90, signaled not only a change in architectural presentation but the beginning of a decade of unprecedented campus growth for Central Michigan University.

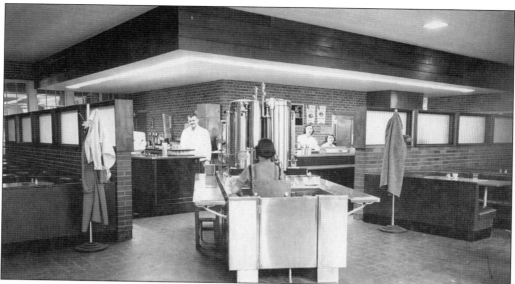

The Keeler Building student union food service area, above, had served the students of Central for two decades of gradual growth and seemed to bespeak a more staid and formal era. The dining room of the new student center, called the Reservation, below, conveyed a lighter, brighter ambiance in keeping with the spirit of a more modern architectural and intellectual reach toward the future that accompanied Central's designation as Central Michigan University (see page 82).

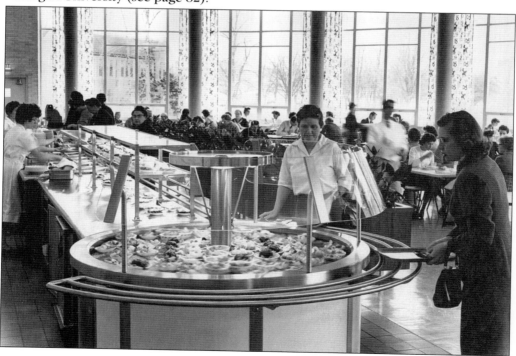

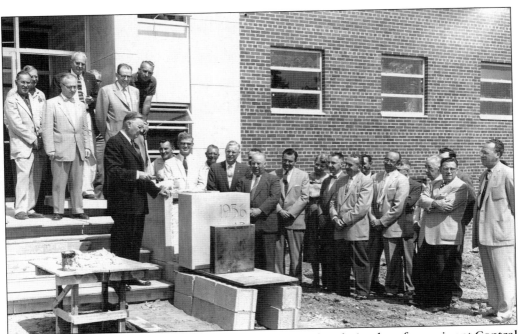

The 1956 dedication of Tate Hall provides a glimpse of a who's who of prominent Central faculty. From left to right are Ron Finch, unknown, Kenneth Bordine, Cleon Richtmeyer, L. M. "Doc" Sweeney (partially hidden), Wilbur Moore, "Wild Bill" Kelly, college president Charles Anspach, Wakeland McNeel, Curtis Nash, unknown, George Lauer, unknown, vice president Judson Foust, Charles B. Park, Louise Sharp, unknown, unknown, unknown, Daniel Sorrels, Roger Cuff, Durrel Emling, Woodward Smith, and Norvall Bovee.

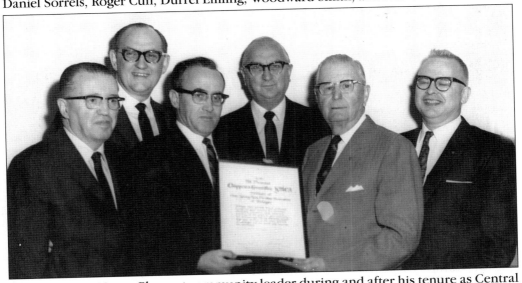

Anspach was a Mount Pleasant community leader during and after his tenure as Central president and until his death in 1977. At the 1968 affiliation of the Michigan YMCA ceremonies, Anspach (second from right) was joined by state YMCA officials (from left to right) George Quillan, Harold T. Kohmeir, and Ino Less, along with Mount Pleasant YMCA dignitaries Armand Ross and John Wolfe.

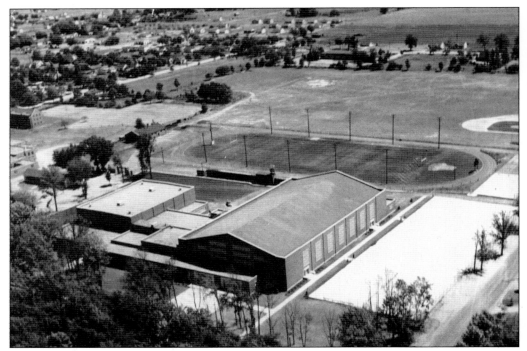

Finch Field House, above, was built in 1951 on Franklin at Preston Streets just southeast of Warriner Hall and just west of the Alumni Athletic Field, and the "old" field house (upper left) and was the largest building on campus at the time of construction. Remodeled in 1968, Finch was Central's main athletic building and the second-largest gymnasium in Michigan, with 4,700 seats, an indoor track including jump pits, and a 30-foot-by-75-foot pool. Finch is now home to the Department of Military Science and the Department of Recreation, Parks, and Leisure Services Administration.

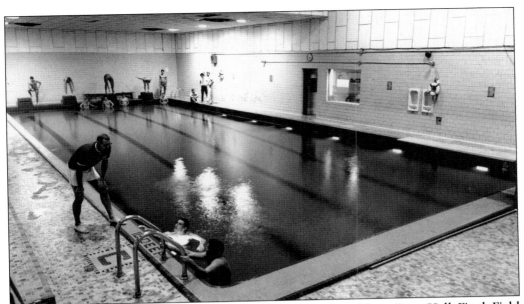

Until the construction of the Student Activity Center (SAC) and Rose/Ryan Hall, Finch Field House was the center of athletic and other events, drawing larger crowds than could be accommodated by the auditorium at Warriner Hall. A major feature of Finch Field House was its indoor swimming pool, above, the first in Mount Pleasant. In the continuing spirit of Central and Mount Pleasant college/community synergy and cooperation, Finch Field House was used not only for Central events but local events such as the Annual Mount Pleasant Home Builders Show, shown below in 1956, among modern community events still conducted on campus.

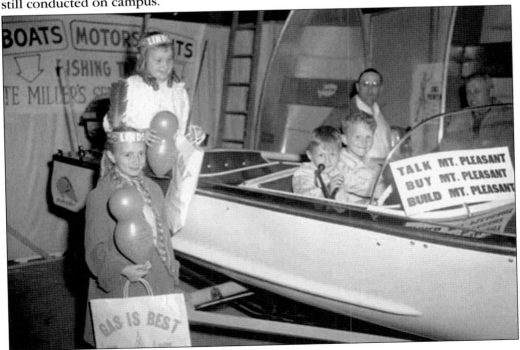

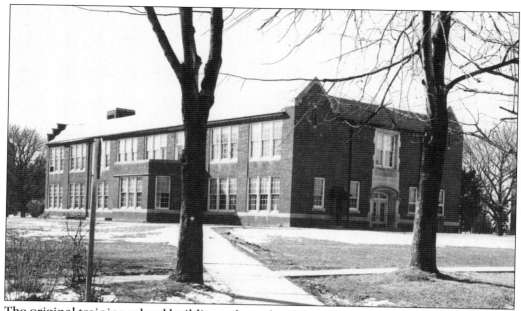

The original training school building, where the children of Mount Pleasant citizens and Central faculty were taught and which provided real-time experience for teacher education for Central students, burned on January 9, 1933 (see page 53). Practically overnight, funds were provided by the state and the debris cleared. More than 125,000 bricks were salvaged by student workers, and those bricks were used as a base for a new running track at the athletic field under construction. The College Elementary School, above and below, was built on the training school site beginning in the autumn of 1933 and opened in time for summer school session in 1934.

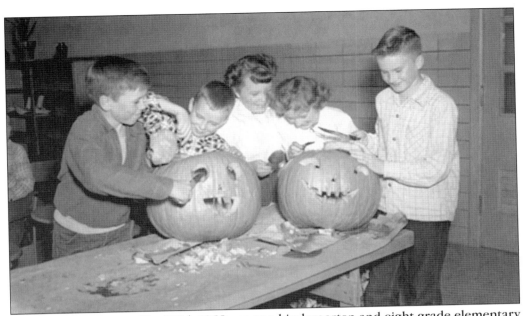

Through the course of its 1934–1958 use as a kindergarten and eight-grade elementary school, where teacher education students worked with local community and Central faculty children, the building now known as Smith Hall was known variously as the College Elementary School, Central Elementary School, and finally the Lab School. Above, "College El" students destined to be in the Mount Pleasant High School class of 1957 work diligently carving pumpkins for an early-1950s Halloween. In 1958, school was out at the core campus elementary school building when the elementary school operations moved to the newly built Rowe Hall. Teaching school laboratories were phased out in favor of expanding student teacher programs in the late 1960s.

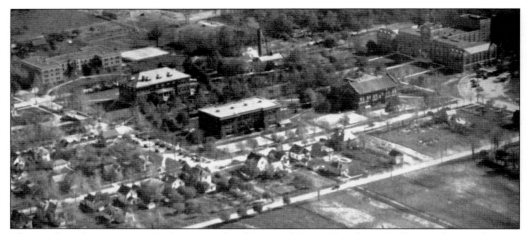

The earliest known aerial photograph of Central State Teachers College, above, depicts the 2,284-student, seven-building campus as it was when Dr. Charles L. Anspach became president of the school in 1939. During Anspach's tenure as president, the name of the institution changed from Central State Teacher's College to Central Michigan College of Education in 1941, to Central Michigan College in 1955, and finally to Central Michigan University in 1959. Below, a later aerial photograph depicts most of the campus expansion during the Anspach years, with the power plant built to the west of the core campus and the sheep sheds in the lower left. Finch Field House to the east and construction south to the small white building at the crossroads at the right would finish with 40 buildings at the time of Anspach's 1959 retirement.

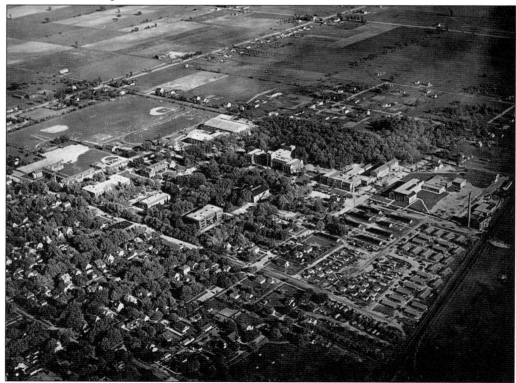

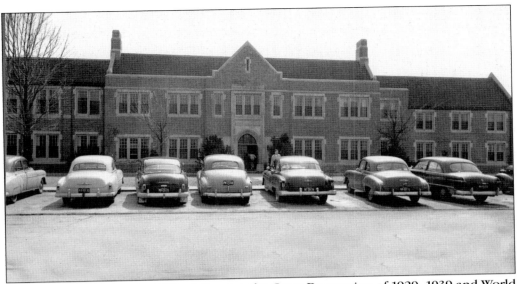

The late 1940s and early 1950s, following the Great Depression of 1929–1939 and World War II rationing of gas and other commodities, saw a rise in the presence of automobiles on the Central campus, as illustrated by the lineup in front of the Keeler Union building, above. The influence of the automobile and a more mobile society has had the impact of widening the geographical scope of the Central student makeup and has seen a dramatic increase in parking lots, nearly to the point where automobile parking lots occupy as much space as buildings on the modern Central Michigan University campus, seen in the view below, looking south from an aerial vantage point just north of the campus proper.

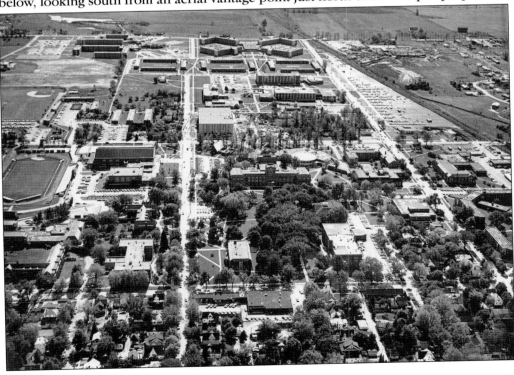

Old Central Hall, the original Physical Sciences Building, above, was headquarters for the ROTC unit when Central was selected as a unit location in 1952. Calling for a two-year basic training program and two years of specialized training, the program paid juniors and seniors $27 a month and they would attend a six-week summer training session. Upon graduation, successful participants in the ROTC program would serve two years active and six years reserve duty. Offered first as an elective, the first two years training quickly became a requirement for all first-year male students under 23 years old and veterans under age 25. At December 6, 1954, ceremonies in front of the ROTC building, Capt. Melvin E. Gustafson, below, was presented the commendation ribbon with metal pendant by Lt. Col. Kenneth Glade.

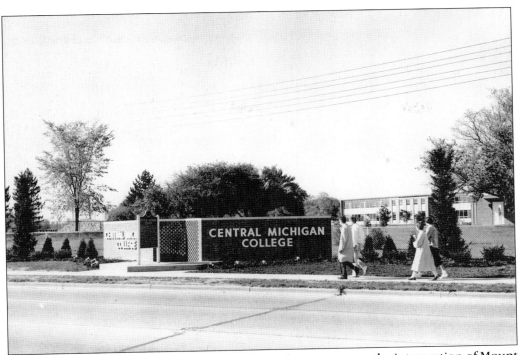

The northeastern perimeter corner of the Central campus, near the intersection of Mount Pleasant's Mission and Bellows Streets, has long been the site of a marker identifying the institution by way of a welcome to visitors as well as incoming students and faculty. In 1958, above looking south, the sign heralded the Central Michigan College name with the newly constructed Rowe Hall in the background right. The modern marker, below looking north with Rowe Hall in the background at left, proclaims the northern perimeter of present-day Central Michigan University, while a similar sign nearly two miles to the south welcomes those approaching from that direction at the southeast corner of the now 480-acre campus.

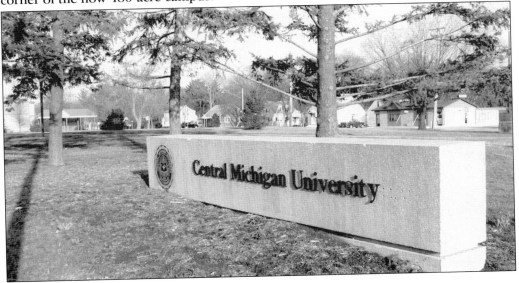

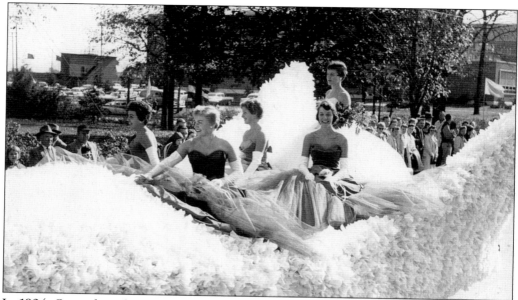

In 1924, Central student Bourke "Dutch" Lodwyk was dispatched to Albion College to scout the school's football team. He returned with the "scoop" on the team and stories of a popular campus homecoming celebration. The first Central homecoming was held in November 1924, featuring a Friday night pep rally, bonfire, and the largest dance of the season. The American Legion festooned downtown Mount Pleasant with flags, and the next morning an automobile parade wended down Main Street to the center of town. Central conquered the Alma College football team 13-0 that day. The homecoming festivities were viewed as a talisman of good luck. Annual homecoming parade festivities have changed little from the 1954 parade spectacle of the Central homecoming queen and court along with floats pledging victory over the homecoming football opponent du jour.

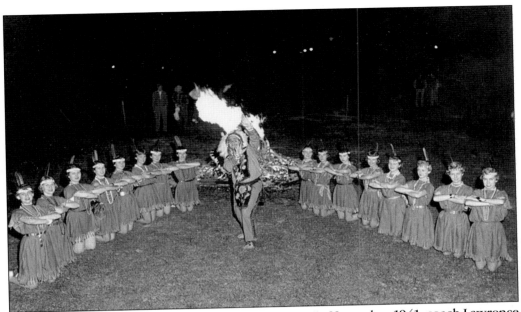

The Bearcats was once Central's athletic team name. In November 1941, coach Lawrence "Doc" Sweeney suggested to the student council the school's athletic team name be changed to Chippewas, pointing out that the Bearcat name "meant absolutely nothing in terms of geographical location" while Chippewa, the name of the school yearbook and the local river as well as the Native American tribal reservation east of town offered "unlimited opportunities for pageantry and showmanship." While blatant characterizations demonstrated by this 1950s pep rally, above, have been discontinued, the name remains in tribute to Central's geography and Native American neighbors, despite the trend of other schools changing their team names. The Mount Pleasant High School teams, named the Oilers, likewise pay tribute to another prominent local entity, the oil industry. Neither Chippewas nor oilmen object to the team names.

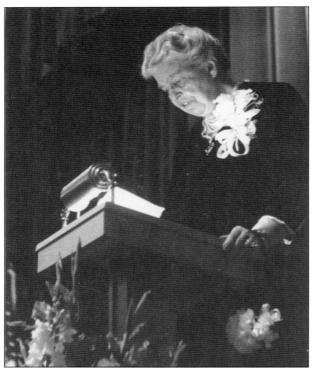

Central attracts leaders of the current era, from presidents' wives in the 1950s to historian David McCullough in early 2007. Former American first lady Eleanor Roosevelt, left, packed the house at Warriner Auditorium the evening of February 16, 1955, in an appearance for an artists course program, advocating United States trade as a way to break through the Iron Curtain. "Must war settle the issue with Russia?" she asked.

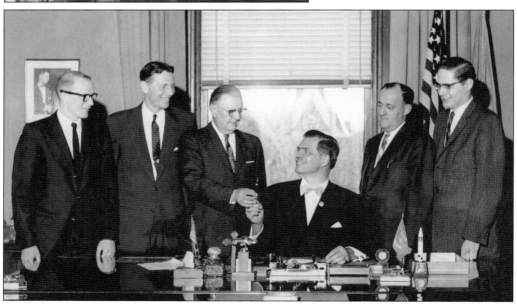

Michigan governor G. Mennen Williams, seated, signed the legislative bill designating Central as Central Michigan University on March 10, 1959, with an effective date of July 1 of that year. Attending the signing at the capitol in Lansing are, from left to right, Central student body president Fred Mester, state board of education secretary Lynn Bartlett, and Central president Charles Anspach, as well as the bill's cosponsors Sen. Lynn Francis and Rep. Russell Strange.

Four

Judson Foust Leads the Building Years
1959–1968

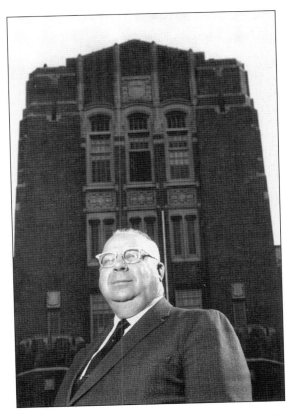

Dr. Judson W. Foust became president of Central on July 1, 1959, the same effective date Central Michigan College became Central Michigan University. Foust, originally from Ann Arbor, graduated from Albion College in 1923 with a degree in mathematics, earned while he also worked for Albion Malleable Iron Works. Earning his masters degree from the University of Michigan in 1927 while he taught at Lansing's Central High School, Foust came to Central in 1929 and earned his doctorate in mathematics from the University of Michigan in 1938. Appointed assistant to the president at Central from 1946 to 1952, then vice president of general academic affairs from 1952 to 1959, Foust was appointed president of Central following Dr. Charles Anspach's retirement.

Dr. Judson Foust's formal inauguration as Central Michigan University president took place in the spring of 1960. Foust and his wife of 35 years, Virginia, pose in the yard of the presidential residence, above, with their five children (from left to right): Jane Foust Legate, Robert Foust, Jean Foust Hocking, Donald Foust, and Janice Foust. Judson retired in June 1968, completing 39 years service to Central. He and Virginia departed the presidential residence, below, for a home they designed along the Chippewa River in Mount Pleasant, where they read philosophy and literature and "took life easy in general." Judson Foust died September 7, 1979.

A frequent sight during the Central presidential era of Judson Foust was Foust at a building dedication ceremony. The 1963 cornerstone laying of Brooks Hall, the first classroom building constructed since 1958, above, saw Foust wielding the trowel with Kenneth P. and Gratia B. Brooks, Florence Dunning, and Faith Johnston (who taught at Central for 46 years). At the 1967 cornerstone-laying ceremonies for Webster B. Pearce Hall, Foust yielded the trowel to Pearce's son but presided over the event. Besides unprecedented campus size and building growth during the Foust era, Central greatly increased its graduate offerings and the university divided into schools.

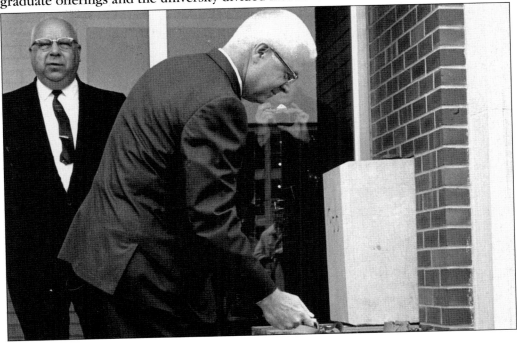

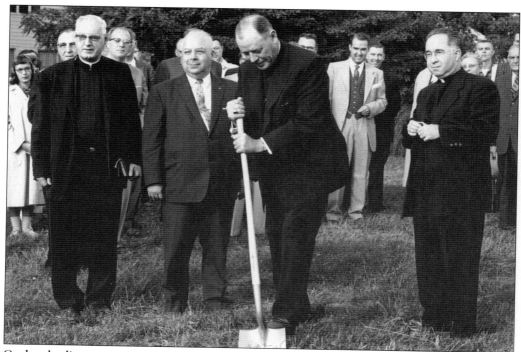

On land adjacent to Central Michigan University donated by Geneva Myrtle Stratton to the Roman Catholic Diocese of Grand Rapids, ground was broken on September 18, 1959, for the St. Mary's Student Chapel by, from left to right, Mount Pleasant Sacred Heart pastor Msgr. Edward Alt, Central Michigan University president Judson Foust, Grand Rapids Diocese bishop Allen Babcock, and Fr. John N. McDuffee, the first St. Mary's Chapel pastor.

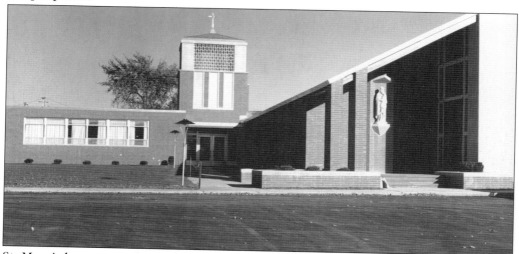

St. Mary's became a Catholic parish rather than a student chapel in 1960. The parish is located on Washington Street just south of Preston Street. By the end of the 1960s, Central Michigan University building growth had leapfrogged St. Mary's Chapel to the south, east, and west, meaning the parish went from being slightly off campus to the south to being in the middle of the Central campus by 1970.

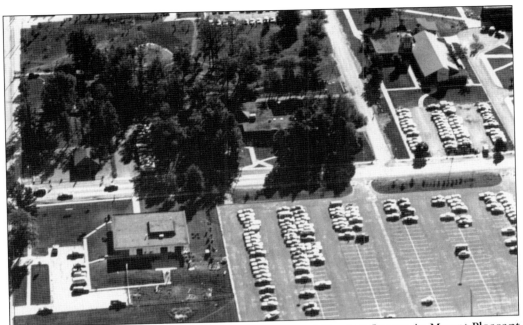

An aerial view of the intersection of Washington and Preston Streets in Mount Pleasant looking east shows the near proximity of the Methodist Wesley Foundation, lower left, Christ the King Lutheran Chapel, across Washington Street, and St. Mary's Catholic Parish, upper right. Stratton made bequests of land to the Roman Catholics, Lutherans, Methodists, and Christian Reform churches.

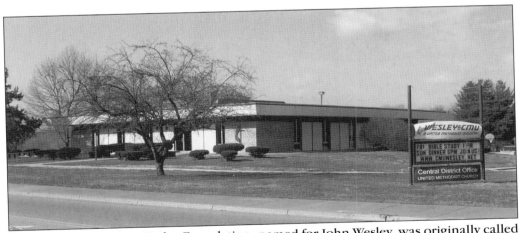

The United Methodist Wesley Foundation, named for John Wesley, was originally called the Wesley Guild. The organization at the University of Michigan is the oldest United Methodist campus ministry in America, begun in 1886. The name was changed in 1923. The Wesley Foundation building at the southwest corner of Washington and Preston Streets, built in 1968, offers a variety of activities, some for all of the campus and Mount Pleasant community.

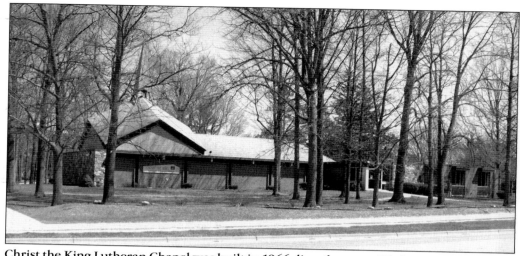

Christ the King Lutheran Chapel was built in 1966 directly across Washington Street from the Wesley Foundation and just north of St. Mary's Catholic Parish, on former farmland bequeathed to the Lutheran Church by Geneva Myrtle Stratton. Originally off campus, the chapel and adjacent office/activities building now reside nearly at the center of the Central Michigan University campus.

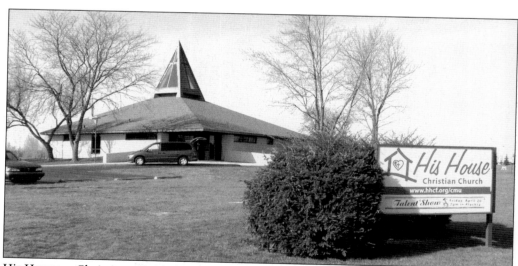

His House, a Christian ministry, was built in 1973 at the south terminus of Mount Pleasant's Washington Street at Broomfield Road on land specifically designated for use only for a church. Details are sketchy regarding if His House was built on land "swapped" by the university for the United Christian Church land bequeathed by Stratton for church use in the Washington-Preston Street area, see pages 86 and 87.

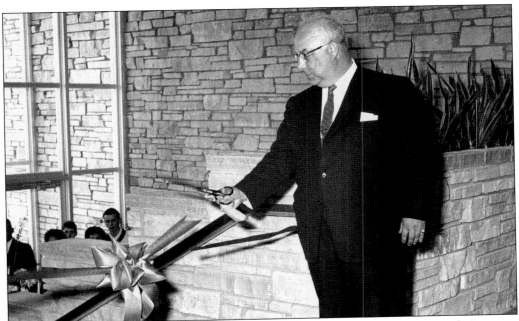

Demonstrating his ceremonial building dedication talents, Judson Foust, above, cuts the ribbon to open the new university activity center in 1960. Foust became adept at opening and dedicating buildings with a trowel and ribbon-cutting scissors during his 1959–1968 tenure. Presentation ceremonies for a portrait of Central Michigan College of Education (1939–1941), Central Michigan College (1955–1958), and Central Michigan University (1959) president emeritus Charles L. Anspach, below, took place at the Bovee University Center in 1964. Shown here from left to right are Central Michigan University president Judson Foust, Anspach, 1904 Central alumnus Perry Shorts, and president of the Central Michigan University Board of Governors E. Allan Morrow.

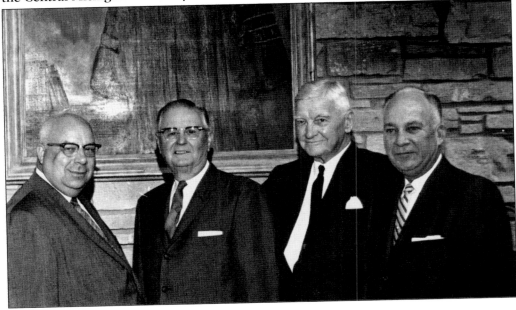

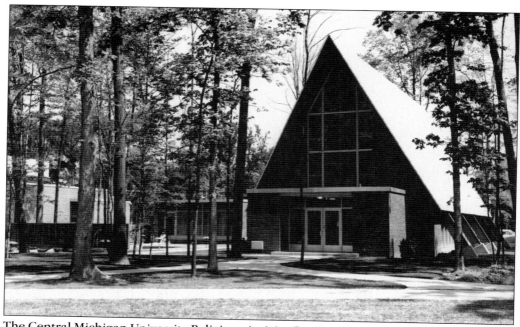

The Central Michigan University Religious Activity Center, above, an interdenominational chapel for multiple religious activities, opened in 1961 at the northwest corner of Franklin and Preston Streets alongside the new student center. Built with a $100,000 "self liquidating" grant approved by the state board of education and the Michigan legislature, the religious center was controversial because of its perceived impropriety under separation of church and state constitutional doctrines. Negative public opinion brought about a change in the building's function from a religious to an artistic venue in later years, when the A-frame structure was redesigned and reopened as the University Art Gallery, below.

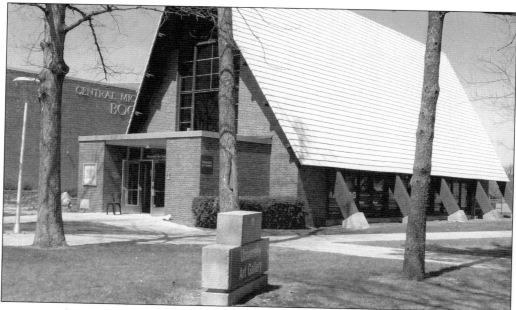

Opening ceremonies, above, saw Central Michigan University's president emeritus Charles Anspach, left, president Foust, fourth from left, and finance vice president Norvall Bovee, right, joined by members of the Mount Pleasant Ministerial Association. Currently, as the University Art Gallery, the building serves as a showcase for resident and visiting artist's works. The gallery was the site of an autumn 2006 showing of the Native American basket collection of Olga Denison (see page 127), a longtime patroness of the university and historical pursuits. The University Art Gallery was a stop on the April 22, 2007, first Annual Central Michigan University Culture Crawl, a tour of the university's cultural hot spots sponsored by Central's Museum of Cultural and Natural History.

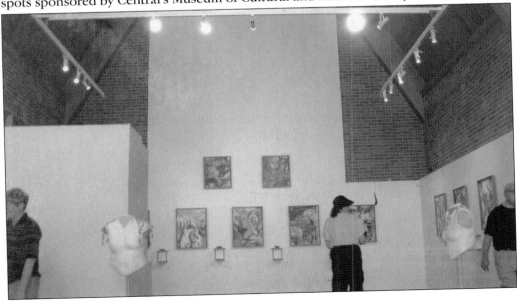

Powers Hall, below, started life in 1938 as Central's first student union and men's dormitory, Keeler Hall, funded as part of Franklin Roosevelt's New Deal during the Great Depression. Navy V-12 cadets were boarded there in World War II. In 1951, the residence portion of the building was renamed Charles C. Barnes Hall. The building housed Keeler Union until the opening of the student center in 1960, then it was remodeled and converted to a music building in 1961, and dedicated as Powers Music Building in 1966 in honor of the 1919–1933 head of Central's music program, J. Harold Powers, left. The exterior of the building, now housing Central Michigan University's Department of History offices, Leadership Institute, and the psychology department, has changed little.

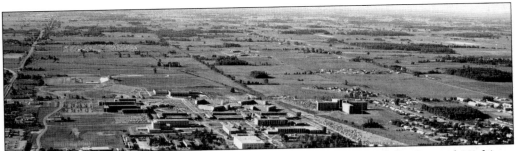

During the Dr. Judson Foust presidential era, the physical size of the Central Michigan University campus expanded, above, southward from Preston Street, foreground, to Broomfield Road, center, in an area bounded by Mission Street, left, and Washington Street, right. During the 1959–1968 Foust tenure as president, Central enrollment almost doubled, the university reorganized into schools and expanded graduate study offerings.

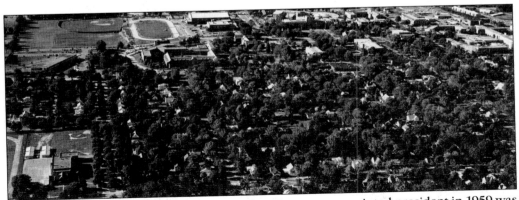

The Central Michigan University campus when Foust was appointed president in 1959 was contained by the railroad tracks to the west, Mission Street to the east (left), Bellows Street to the north (foreground), and Preston Street to the south (top). In the Foust presidential years, 1959–1968, the size of the Central campus doubled, the library size quadrupled, and eight residence halls and three major classroom buildings were erected.

Located on 130 acres along the eastern shore of the 58-square-mile Beaver Island in Lake Michigan, the Central Michigan University Biological Station offers a variety of spring and summer courses as well as providing research facilities all through the year. The biological station, nearly 200 miles northwest of the Mount Pleasant campus, was established in 1966 and, with the nearer Nethercut forest preserve in Clare County, offers a variety of habitats for nature and biological study to Central graduate and undergraduate students. Beaver Island biological station is primarily devoted to research and studies while Nethercut also avails itself to leadership retreats for students and faculty.

Beloved by students, faculty, and administration, the location of Central Michigan University Biological Station on remote Beaver Island makes the facility, above, an ideal center for the study and research of various beaches, shoreline and forest vegetation, snakes, hawks, fish, and animals in a surrounding practically undisturbed by human activities. Shortly after the establishment of the station, Central Michigan University leaders used the locale as the site of informal conferences. Below, a group including (from left to right) Woodward C. Smith, Paul Winger, Don Carr (back to camera), unknown, Gil Maienknect, retired Central Department of Conservation and Agriculture head George Wheeler, and Charles B. Park enjoy the rustic atmosphere of the station.

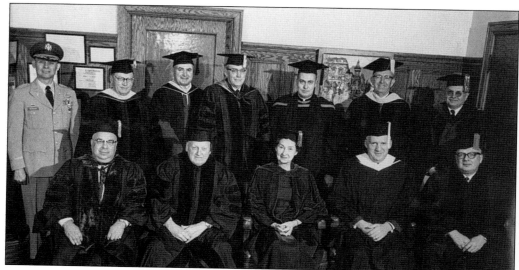

The 1968 Central Michigan University graduation ceremonies were the last in the Foust presidential era presided over by faculty and board of governors members. From left to right are (first row) Central president Judson Foust, Dwight Rich, Dr. Susan B. Riley, Frank Hartman, and Virgil Rolland; (second row) Colonel Fossum, Woodward C. Smith, Carlo Barberi, Dr. Wilbur Moore, Fr. John Goodrow (St. Johns Episcopal Church, Mount Pleasant), Dean Sorrels, and Dean Cleon Richtmeyer.

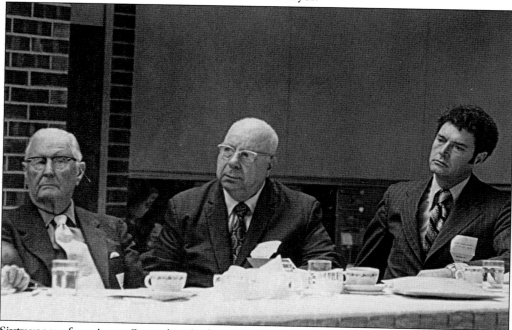

Sixty years of service to Central and 36 years as the institution's president were represented at a 1968 banquet. Dr. Charles L. Anspach (left) served Central as president through three school name changes from state school to college to university from 1939 to 1959. Judson Foust's 39-year career at Central included nine years, 1959–1968, as its president. William B. Boyd (right) served eight years as Central Michigan University president, 1968–1975.

Five

THE TIMES THEY ARE A-CHANGIN'
1968 AND BEYOND

Mount Pleasant, South Carolinian William B. Boyd followed up a 1943–1946 U.S. Navy deck officer and navigator stint earning his bachelor of arts in 1946, master's degree in 1947, and doctorate degree in 1954. Boyd was on the faculties of Michigan State University, Alma College, and the University of California-Berkley before coming to Central. Vietnam War protests, resistance to the draft, anti-military demonstrations, student rights issues, the Watergate Scandal, Pres. Richard Nixon's resignation, and the Arab Oil Embargo all caused national citizen discontent to visit campus during the 1968–1975 Boyd tenure as Central Michigan University president. Boyd accepted the presidency of the University of Oregon in 1974, leaving Central a legacy of coed dormitories, relaxed residence hall curfews, and an expanded degree program as well as new academic and athletic facilities.

Asserting "It would be a tragedy if our young people did not react to this sad affair," Boyd, center above, joined Central Michigan University campus events protesting the Vietnam War in a huge demonstration calling for a moratorium on fighting during peace negotiations in the fall of 1969. The weekend demonstration included a candlelight vigil and march to downtown Mount Pleasant, above, attracting several thousand students, faculty, and community citizens in protest of the war. This occurred the same week as Greek Week, but students delayed those festivities for a week to let fraternity and sorority members participate in the demonstration, wherein the Central campus mall was lined with white crosses representing the American Vietnam war dead.

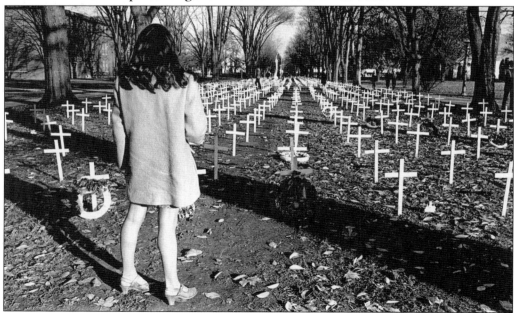

In March 1970, some students, including Tom Hayes, right, "took over" Central Hall, the ROTC building, renaming it Freedom Hall in protest of America's decision to send troops into Cambodia. Vowing to occupy the building until their demands were met for a student vote on continuing ROTC and military recruiter presence at Central, as well as amnesty for the sit-in members, the students left Central Hall after five days, proclaiming their point was made. Boyd, below, needed his experience as a naval officer and vice chancellor of student affairs at the University of California-Berkley to end the sit-in. Encouraging the acceptance of new ideas, freedom, and innovative teaching, Boyd is best known for his handling of Vietnam War–angered student demonstrators and his call for calm in the face of the protests.

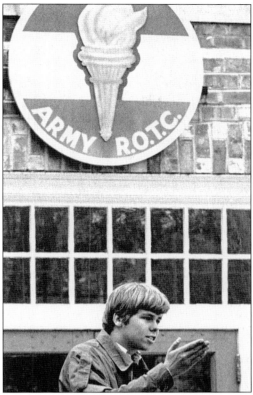

The Central Michigan University Museum of Cultural and Natural History serves as a laboratory for higher education and public museum and is a repository for many donated items including preserved plants and animals and lumbering and pioneer tools as well as the university's collections of anthropological, biological, geological, and historical artifacts. Central museum field career–bound students curate the museum's collections, as well as conducting public tours of the exhibits.

Originally housed in the log cabin on the next page, the Central Michigan University Museum of Cultural and Natural History was located in what is now Ronan Hall from 1971 until moving to Rowe Hall in 1975, locating in the gymnasium area of the part of Rowe once occupied by College Elementary School from 1958 until closing in 1970 in the face of the growing community student teacher program.

The 1845 log cabin known as the Alumni Museum was located in the wooded strip just behind Warriner Hall between Warriner and Preston Streets. Preserved to depict pioneer life in Michigan, the cabin was disassembled when the forest was razed in the late 1950s to make room for the student center and has never been seen again.

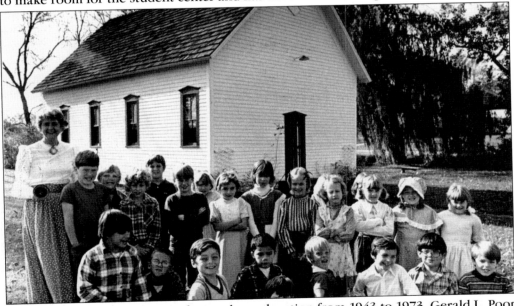

Named for Central professor of secondary education from 1943 to 1973, Gerald L. Poor School Museum is located in the Bohannon one-room school. Built in the 1880s and operated until 1950 in Midland County, Bohannon School was purchased by Mount Pleasant Realty, donated to Central in the early 1970s, transported to the campus in two parts gratis by Mount Pleasant excavator Fred Grewe, and preserved by volunteer labor with donated materials.

Special Olympics was founded in 1963, believing people with learning disabilities can enjoy and benefit from individual and team sports participation, with suitable instruction and encouragement. The 1968 First International Special Olympics Games were held at Central Michigan University, establishing a tradition continuing to modern times. Over 12,300 athletes compete in the Special Olympics of Michigan's year-round programs.

The Special Olympics of Michigan Central Region office, near the northeast corner of the Central Michigan University campus, is a former home of the Michigan State Highway Department Mount Pleasant facility, becoming one of six region offices in Special Olympics Area 8 in the 1980s. The Central Region office at Central Michigan University serves Arenac, Bay, Clare, Genesee, Gladwin, Gratiot, Huron, Isabella, Lapeer, Midland, Saginaw, Sanilac, Shiawassee, St. Clair, and Tuscola Counties.

Two varied long-standing and enjoyable Central campus traditions from serious to sublime are depicted here. Above, from left to right, at the 1973 Central homecoming football game, Central alumni director Bill Odykirk, Eastern Michigan University athletic director "Frosty" Ferzacco, Central president emeritus Charles Anspach, Central Michigan University athletic director Ted Kolhede, and Eastern alumni director Lenny Head look a little chilled as Eastern presents Central the game winner's trophy. On a warmer note, below, a 1970s Michigan springtime brings a bevy of sunbathers near the Towers residence halls into full bloom.

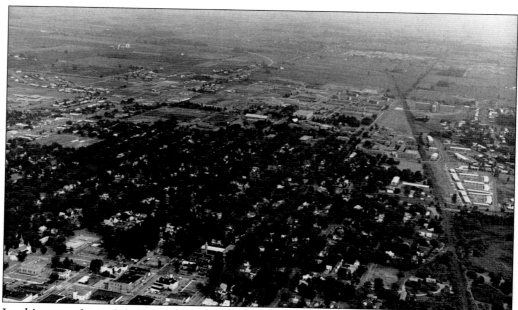

Looking southward from an aerial vantage point over Mount Pleasant's Island Park in the 1970s, with downtown in the foreground, underlines the near proximity of Central Michigan University (beginning mid-photograph defined by the U-shaped Northwest Apartments, right center) with the center of the community. Mount Pleasant residents have long enjoyed having Central in the community's backyard. Likewise, below, a look northeasterly from the air just south of Broomfield Road in the 1970s (the construction site in the foreground is the beginnings of Rose Arena) of the town, lying between the West Intermediate School in to open space at upper left and the old sugar beet processing plant marked by the upper right, handy to and "in the front yard" of the Central Michigan University campus.

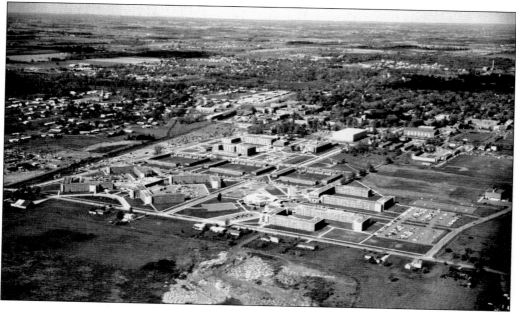

New Yorker Dr. Harold Abel was a faculty member at Syracuse University, the University of Nebraska, and the University of Oregon and president of Castleton State College in Vermont before coming to Central Michigan University as president in 1975. Serving as president from 1975 to 1985, Abel is best known for maintaining steady enrollment in the face of national decline and leading the university through financial crisis as tighter funding for higher learning institutions became the norm.

Industrial arts students in one of the many shop venues of Wightman Hall reflected the "keep working" attitude of Central Michigan University during the 1975–1985 decade, inspired by Abel's leadership during a quiet period for expansion as Michigan faced scanter economic times during a recession and manufacturing slump that saw the state labeled part of "the Rust Belt," causing universities to wrestle with slimmer budgets.

As mentioned back on page 27, in 1924, the first residence hall on the Central campus was dedicated in the name of Bertha N. Ronan, physical education professor from 1903 to 1923 and dean of women from 1923 until her 1943 retirement. The original Ronan Hall was demolished in 1970 because of structural concerns. When the Charles V. Park Library moved to new quarters, the former library building was renamed in honor of Ronan.

Built in 1955 as a library, home to the Charles V. Park and Clarke Historical Libraries until 1969, Bertha Ronan Hall has housed the Center for Cultural and National History (from 1971 until the center's 1975 move to Rowe Hall) and the university's closed-circuit television studio. The building now is headquarters for the Affirmative Action Office, Department for Teacher Education and Professional Development, and College of Education and Human Services.

Arthur Emmett Ellis served as Central Michigan University president from 1986 to 1988, turning a $1.9 million university deficit to a small surplus, ushering enrollment increases and new growth for the campus. With a masters degree in higher education, Ellis was executive director of governmental relations and university budgets for Eastern Michigan University from 1968 to 1970 and vice president of public affairs for Central Michigan University from 1970 until he was appointed interim Central Michigan University president in 1985 and president in 1986. Known for his problem-solving ability to get things done and his dedication to the support of public arts, Ellis retired in 1988 and was appointed to serve as the director of the Michigan Department of Commerce, then as superintendent of public instruction for the Michigan Department of Education. On April 25, 2007, a statuary on campus was dedicated to Ellis (see page 112).

Central Michigan University president from 1988 to 1992, Edward B. Jakubauskas, originally from Connecticut, with a doctorate degree in economics, served in a number of government and university positions in Washington, D.C.; Iowa; and Wyoming before his appointment to the Central presidency in 1988. During his tenure, construction began on the Dow Sciences Complex, Alumni House, and Applied Sciences Complex. Jakubauskas is also remembered for emphasizing global education and recruiting minority students and faculty.

The combined services building was opened in 1989, during the Jakubauskas Central Michigan University presidential era. The 70,000-square-foot building, located just west of the university power plant on East Campus Drive, houses a number of university service facilities including the Central Michigan University Police Department, the educational materials center, facilities management, printing services, university stores, and the university mail room.

Leonard E. Plachta, as Central Michigan University president from 1992 to 2000, focused on developing effective academic programs, treating students as customers through improved student services, and creating an efficient management. Plachta was dean of the College of Business Administration when appointed interim president in 1992, then president in 1994. He was an Alma College and University of Detroit faculty member before joining Central in 1972 as an accounting professor.

In 2000, the 1,500-seat auditorium in Eugene C. Warriner Hall was renamed in honor of Central president emeritus Dr. Leonard E. and Louise A. Plachta. The auditorium has served Central Michigan University, with upgrades, since 1928, acting as home to thousands of stage and musical performances, graduations, and other ceremonies. The auditorium's dedication to the Plachtas reflected their love for the performing arts.

"The father of Central's track program," Lyle F. Bennett earned two letters each in baseball, football, and track at Central. After coaching at several high schools, he returned to coach Central football from 1947 to 1949, founding a track team he coached from 1947 to 1970. Bennett's football coaching established an 8-15-1 record, while his track coaching scored a 118-81 record. Retiring in 1970, Bennett died on March 1, 2005, in Mount Pleasant at age 101.

Lyle F. Bennett Outdoor Track, with grandstand seating for 1,000 spectators, a press box, an automatic timing system, and a scoreboard, opened in 1999 just west of the student activity center. The 400-meter track features eight running lanes, nine sprinting lanes, and dual runways with three available pits for the long/triple jump and pole vault. The throwing area features two discus/hammer cages, two shot put rings, and three javelin runways.

Originally from Florida, Michael Rao was chancellor of Montana State University Northern and president of Mission College in Santa Clara, California, before his August 1, 2000, appointment as Central Michigan University president. His experiences also include dean, consultant to higher education institutions, and assistant to the president of a top research university. The president's wife, Monica Rao, serves as the university outreach liaison and is a professional watercolorist and graphic designer.

The Central Michigan University Health Professions Building, home of the Herbert H. and Grace A. Dow College of Health Professions, opened in 2006 where Alumni Athletic Field once stood on Preston Street at East Campus Drive. The 175,000-square-foot, two-story structure contains laboratories and classrooms. Perimeter corridors connect clinical, instructional, and research segments with therapeutic courtyards providing several health professions programs with rehabilitative qualities.

Symbolizing the unity of Central Michigan University and president Rao, center, with the Saginaw Chippewa Indian tribe, a statuary named *Gete-Achitwa-Asinakwe* (Ancient Honorable Stone Woman) by Chippewa Native American artist Jason Quigno, standing second from left with his mother, was dedicated on April 25, 2007, next to the university art center in honor of Central Michigan University president emeritus Arthur Ellis, right, who helped found the Michigan Council of Arts and Cultural Affairs, and, according to the sculpture's plaque, "initiated the Central Michigan University public art program and promoted the importance of public art in the lives of the Mount Pleasant and campus communities."

Six

TRANSITIONS
CAMPUS EVOLUTION

Just outside the north perimeter of Central's campus, Mount Pleasant merchant H. G. Gover, recognizing the business opportunity available by offering goods to the students stranded on the "remote" Central campus just across Bellows Street and nearby student boarding, opened his grocery and school supply store at the south terminus of Normal (now University) Street at Bellows Street in the mid-1890s.

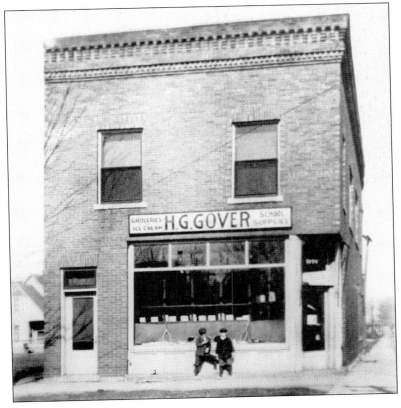

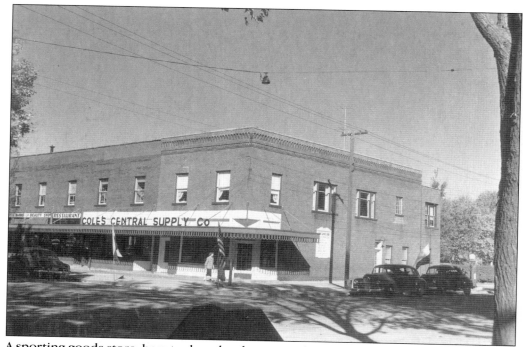

A sporting goods store, beauty shop, bookstore, and restaurant were added to the Gover enterprise, and by the late 1940s, above, the building at University and Bellows Streets was anchored by Cole's Central Supply Company. Cole's later added on to the back of the building and moved into that wing, putting the University Shop, a clothing store, on the corner. The entire structure burnt to the ground in 1963. The shopping complex at the corner of University and Bellows Streets was rebuilt as the Campus Plaza containing the Student Book Exchange book and student supply store. The shopping center and its former tenant, now neighbor, the Malt Shop, below, remain favorite student venues.

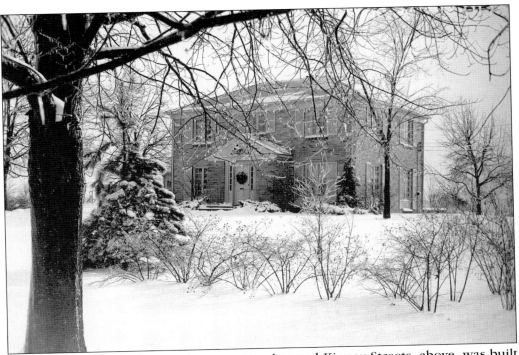

The house on Bellows Street between Fancher and Kinney Streets, above, was built as a private residence in 1941 and purchased by Central in 1944 to be the home of Central's chief executive. The residence would be occupied by four Central presidents. Conversion of the house into an alumni center was complete in 1990. The restoration and expansion included the addition of a conference room, reception areas, staff offices, and workrooms, below. The modern Carlin Alumni House (see page 61), with its display of campus photographs dating from 1892, Chippewa yearbooks from 1910 on, and a library of books written by Central Michigan University alumni, as well as several areas to sit, relax, and reminisce about student days, serves as a home base for visiting graduates and special alumni events and also as the office building for the alumni and development staffs.

Charles V. Park was director of Central's library from 1930 to 1957. Born in Kansas, Park earned a bachelor of arts degree from Stanford University in 1909, serving that institution as assistant librarian from 1910 to 1930. Retiring from Central as head librarian in 1957, Park oversaw two library moves: from Warriner Hall to the present Ronan Hall on Washington Street in 1956. The first Preston Street building move, next page, was made after his retirement. Park died in 1982.

Dr. Norman E. Clarke Sr., father of the Clarke Historical Library developed a love for books and collecting as a boy in Mount Pleasant. Born the same year as Central was created, Clarke received a teacher's certificate from Central Michigan Normal School in 1913 and then went on to ultimately become a cardiologist. His 1954 donation of his historical book collection to Central founded the Clarke Historical Library, housed in Park library buildings since.

The faculty and staff of the Central Michigan College Library in 1959 includes, from left to right, Bernard Toney (library), Mary Bradac (reserves), Alexander Vittands (Clarke Historical Library cataloguer), Arlene Grimley (circulation), John Cumming (Clarke Historical Library director), Brian Clendening (media services), Mary Garvin (head of periodicals), Orville Eaton (head of the library from 1958 to 1968), Art Fish (government documents librarian), and Jim McTaggert (acquisitions).

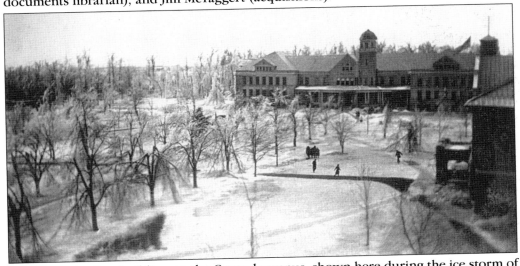

Old Main, the first building on the Central campus, shown here during the ice storm of 1922, was home to the school's library until the building was destroyed by fire in 1925. The library was left with only those books checked out by students as a core inventory. Resources previously planned to build a new library building were devoted to replacing Old Main with Warriner Hall.

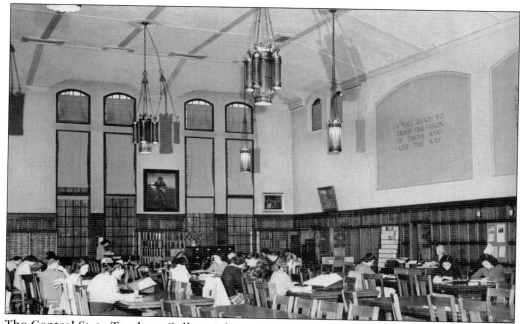

The Central State Teachers College Library opened in Warriner Hall's library east wing in 1928 with a two-story reading room that could accommodate 250 students and 10,000 volumes, with an adjoining room holding the balance of the library's books, numbering 18,000 total in 1928 and 30,000 items by 1933. The library at Warriner served the school from 1928 until a new library was constructed in the early 1950s.

A new building, currently Ronan Hall, opened in 1956 to house Central's Charles V. Park Library and Clarke Historical Library, replacing the last of the original campus buildings with 60,000 square feet, allowing plenty of room for the 90,000-volume book collection along with 750 study seats, seminar rooms, manual typewriters for student use, and record listening rooms. By the mid-1960s, the 8,200-student enrollment and 170,000-item collection rendered the building inadequate.

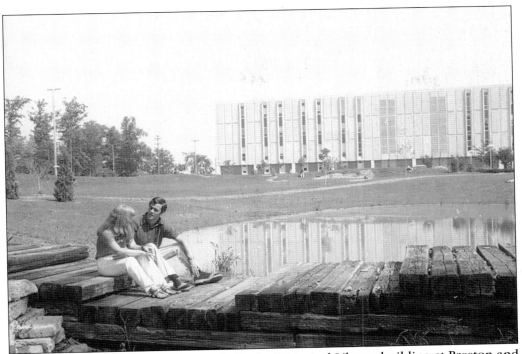

The new Charles V. Park Library with Clarke Historical Library building at Preston and Franklin Streets, the location of the present library, boasted 173,500 feet and 2,285 study seats but retained the manual typewriters from the previous building when opened in 1969 with the patterned aluminum sheathing, later removed. The computer age prompted the need for a new advanced technology–friendly library building in the late 1990s. The building was razed in 2000.

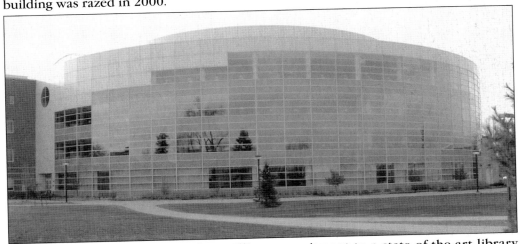

Central Michigan University's $50 million commitment to a state-of-the-art library project has Charles V. Park and Clarke Historical Libraries into electronically supported 21st-century information centers opened in 2002, following a period where both operated from temporary headquarters. The new library building has nearly three times as much seating space, an array of new technology-based services, and resources and space for up to 1.3 million print volumes.

The Clarke Historical Library, above, is one of Michigan's leading research libraries, documenting the history of Michigan and the old Northwest Territory, published works that shape the minds of young children, and the history of central Michigan. Clarke Historical Library cooperates with a number of entities to provide exhibits throughout the year. At the 2005 opening of the Michigan Oil and Gas exhibit, below from left to right, Western Michigan University geology professor William Harrison III and Central Michigan University dean of libraries Tom Moore discussed the exhibit in the background while Michigan Oil and Gas Association (MOGA) vice chairman Tom Mall, MOGA chairman Jim Stark, MOGA president and 1971 Central graduate Frank L. Mortl, Clarke Historical Library director Frank Boles, and *Michigan Oil and Gas News* contributing editor Jack R. Westbrook pose in front of a freestanding photograph display.

Seven

THE MODERN CAMPUS
BUILDING ON TRADITION

Central Michigan University's music building is three separate buildings joined by silicone and rubber joints. Fifteen rooms are named for luminaries and donors. The building opened in September 1997, featuring 119,000 square feet of classrooms, a 500-seat recital hall, a 110-seat chamber music hall, lecture and rehearsal rooms, music technology laboratories, teaching studios, practice rooms, offices, and a 30-station music resources center for listening to record albums, cassette tapes, and compact discs.

The SAC, built in 1990 as a 175,000-square-foot addition to Rose Center, houses an Olympic-sized swimming pool; racquetball, basketball, and volleyball courts; a bowling alley; and conditioning rooms with Nautilus equipment and free weights, offering students and community members a wide variety of activities including aquatics, aerobics, fitness training, jogging, billiards, indoor soccer, archery, table tennis, badminton, tennis, floor hockey, dancing, and leisure activities.

Opening in March 1999, the Central Michigan University indoor athletic complex houses the Jack Skoog Indoor Track for men's and women's track and field competitions. The facility also provides practice space for softball, baseball, field hockey, women's soccer, and football. The facility also houses a weight room, training room with a hydrotherapy pool, and an academic center with computer facilities and study space and rooms for academic advising, tutoring, and meetings.

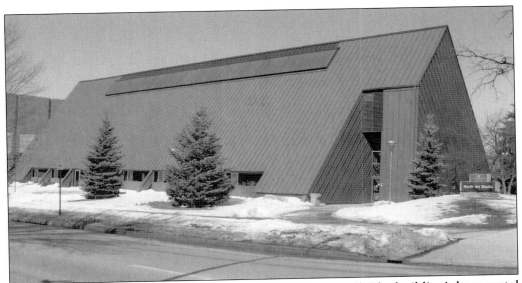

North Art Studio was built in 1976 adjoining Wightman Hall. The building's bare metal exterior caused a great deal of concern when it began to oxidize as those who did not grasp the vision of the designers did not realize the object of the exercise was to let the rusting process find its way to today's patina. Students create unique works of art at the North Art Studio.

The Central Michigan University Dow Science Complex is named for Herbert H. and Grace A. Dow Foundation of Midland. The complex is a four-level state-of-the-art facility containing 70 teaching and research laboratories in the west segment of the campus. The complex opened in 1992 to house the chemistry department, the geography department, and the physics department.

Opened in 1989, the Industrial and Engineering Technology Building features extensive laboratory space for electronics, robotics, automotive systems, and graphic arts. The Central Michigan Industrial and Engineering Building boasts a Michigan Council of Arts and Cultural Affairs–funded sculpture in front and Native American artist–designed flooring inside, in addition to providing students seeking technical experiences with a program and facility on the cutting edge of 21st-century technology.

The greenhouse adjacent to Brooks Hall in the south campus area, opened in 2002, gives Central Michigan University students a unique and special venue for their studies, with the opportunity to work with plants not indigenous to Michigan. The greenhouse features computerized air temperature controls and will support plants from a variety of ecological systems, including tropical rain forests and deserts.

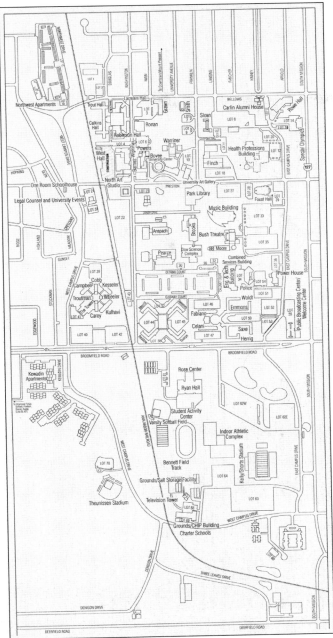

At the June 17, 1928, dedication of Warriner Hall, named for the Central State Teachers College president from 1918 to 1939, Eugene E. Warriner predicted, "While we have made many changes in the past few years, we feel we have only begun to develop and to grow." Comparison of the campus on page 18 with this current Central Michigan University campus map seems to fulfill Warriner's vision, along with that of the unsung thousands who have along the way made the university of today a springboard to an expanded future. This progress has come about through the generosity of time and financial support by generations of students, faculty, and alumni along with the general community.

Ideal examples of the synergy between Central Michigan University and the general community are the campus associations and boards whose memberships include prominent university and general population representation. Here the Central Michigan University Development Board of 1993, on an internal university stairway, includes from left to right, (first row) Ted Kortes, Randy Robertson, and Dr. Janice M. Reynolds; (second row) Al Cambridge, Keith Feight, and R. G. "Rollie" Denison; (third row) Roger Kessler, Sue Dupree, Helmut Schluender, and Jack Weisenburger; (fourth row) Jerry Tubbs, Wendy Foss, Dr. Leonard Plachta, and Dr. Gordon Lambie; (fifth row) Harvey Schroeder, Tom Moore, and Mike Hayes; (sixth row) Ron Heath, Kathy Sanders, Steve Falk, Susan Leonard, Bob Rulong, and Carol Furrow.

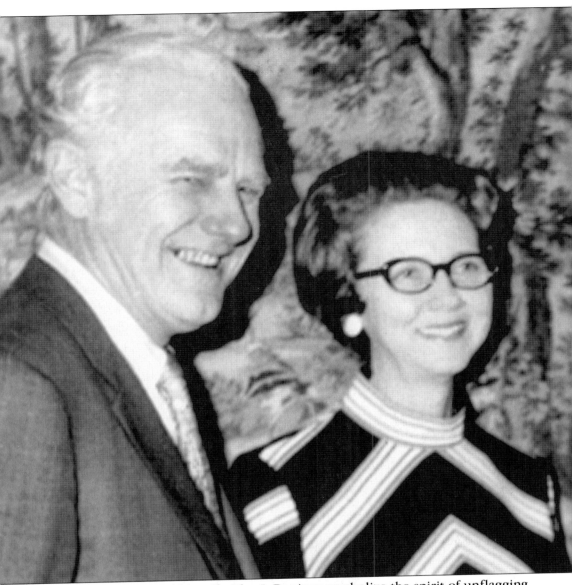

The late R. G. "Rollie" and his wife Olga J. Denison symbolize the spirit of unflagging generosity of time and resources, commitment to city, and university-community involvement. The Denisons began their lifelong romance with Central, the Mount Pleasant community, and each other when both were Central students in the late 1930s. They were married in 1941. On campus, the Denisons established scholarship funds, as well as supporting arts, athletics, business studies, libraries, and much more as Rollie's success in the Michigan oil and gas industry ascended. In community service leadership, the list of their accomplishments is prodigious. Rollie was Mount Pleasant mayor and president of the Michigan Oil And Gas Association from 1970 to 1971 while Olga's civic and cultural activities are local legend. Each was selected as Mount Pleasant Chamber of Commerce Citizen of the Year on separate occasions.